TAILS
from the
EXOTIC
FELINE
Rescue Center

QUARRY BOOKS

an imprint of
INDIANA UNIVERSITY PRESS
BLOOMINGTON & INDIANAPOLIS

25th Anniversary Edition

TAILS
from the
EXOTIC
FELINE
Rescue Center

Stephen D. McCloud and Joe Taft

Foreword by Bill Nimmo

This book is a publication of

Quarry Books
an imprint of
Indiana University Press
Office of Scholarly Publishing
Herman B Wells Library 350
1320 East 10th Street
Bloomington, Indiana 47405 USA

iupress.indiana.edu

The paper used in this publication meets
the minimum requirements of the
American National Standard for Informa-
tion Sciences—Permanence of Paper
for Printed Library Materials,
ANSI Z39.48-1992.

Manufactured in China

Cataloging information is available
from the Library of Congress.

ISBN 978-0-253-02201-1 (paperback)
ISBN 978-0-253-02411-4 (cloth)
ISBN 978-0-253-02211-0 (ebook)

1 2 3 4 5 21 20 19 18 17 16

Cleo, 2011, page i; Kya, 2013, page ii;
Zeus, 2014, page iii

Thor and Zeus, October 30, 2011

*May the time come when all men will recognize
the fact that the laws of God and humanity
require us to be merciful to the dumb animals, and to
grant the same justice and mercy to them
we would ask for ourselves.*

INDIANA AUTHOR Gene Stratton-Porter,
The Strike at Shane's

Contents

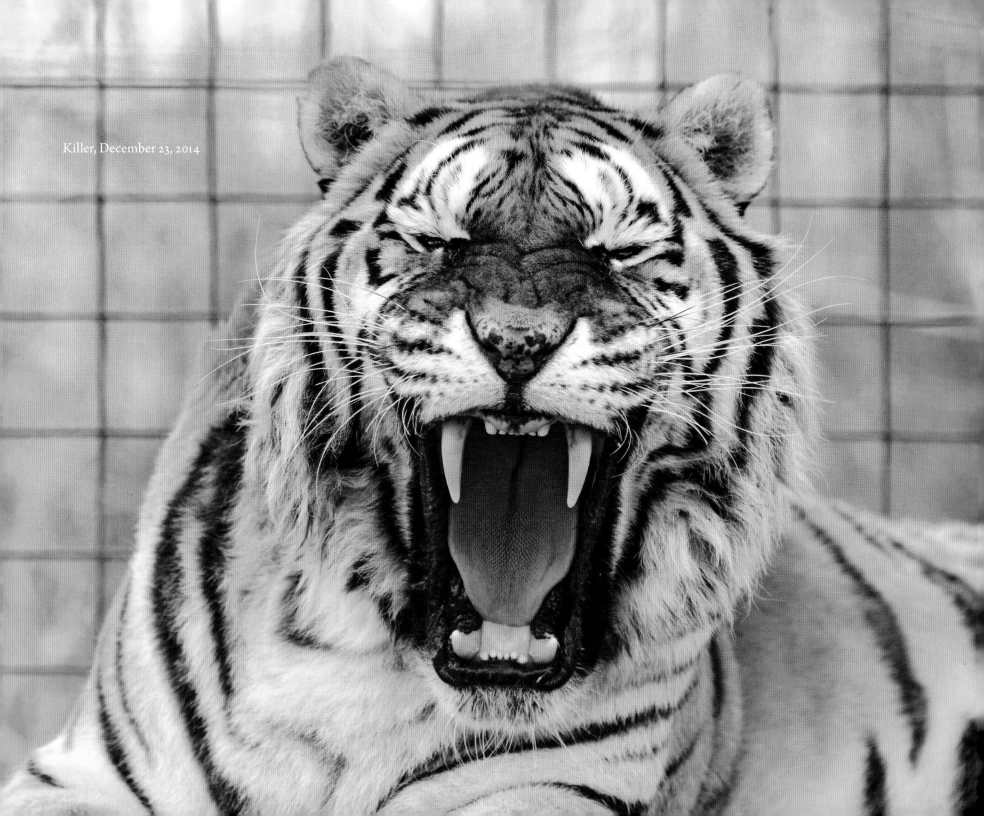

Killer, December 23, 2014

Foreword

In the summer of 1996 my wife and I traveled to southern New Jersey to visit our friends Joan and Jan, who kept a number of tigers on their property: Jaipur, the largest, at seven hundred pounds; Maya, the kindest; and two of the most striking tigers we have ever seen, young brothers Sahib and Sultan. The occasion was the recent birth of three cubs. We spent a memorable day feeding and playing with them and over the next two years made return trips to help out and watch the cubs grow. But as work pressed our time we made fewer and fewer trips and eventually lost touch.

Fifteen years later in June 2011 we received a call saying the tigers were gone, confiscated by the state in 2003 and shipped to an animal sanctuary in Texas. Their removal was brought about by the shooting of a tiger that wandered into the nearby town. Since Great Adventure, an amusement park with tigers, was in the same area, the incident led to an investigation. It was unclear from which facility the tiger escaped, but after six years of legal wrangling and deteriorating conditions at Joan's facility the state decided that the tigers must be removed.

That phone call prompted our concern about the fate of the tigers we knew as cubs, so we contacted a number of animal welfare organizations. They identified the sanctuary as the Wild Animal Orphanage (WAO) in San Antonio, which had gone bankrupt in 2010, leaving three hundred animals homeless. The information we received was not encouraging. The New Jersey tigers might have been there but identifying a specific tiger would be almost impossible. There are thousands of tigers in this country and their life span is twenty years in the best of conditions; without a proper diet and vet care the probability that they were still alive was remote. The welfare organizations' advice was to not bother trying to find them: "All those tigers," they told us, "are probably dead."

It didn't sound right, or maybe we didn't want to believe it, so I continued to inquire. Then I spoke to Patty Finch, the executive director of the Global Federation of Animal Sanctuaries. She said that Carole Baskin at Big Cat Rescue in Tampa, Florida, might be able to help.

Armed with a list of the New Jersey tiger names, I went to Florida to meet Carole. She said WAO still had some tigers alive but couldn't be sure about their identities. The only sure way to know was to match the stripe patterns. Every tiger has a unique pattern, so if we had any old pictures they might be able to do something. Fortunately my wife kept pictures of the cubs, so the challenge was to get pictures of the adult tigers at WAO.

Jamie, Carole's daughter, happened to be on her way back to Florida from a rescue out west. Carole rerouted her to San Antonio and made arrangements to get her into WAO. Twenty-four tigers had been transferred there from New Jersey in 2003 and since their arrival many had died and some had gone missing, but seven remained alive. Jamie, along with Mary and Michelle, the only remaining keepers, were able to get pictures of the tigers. Jamie continued on home to Tampa and began the process of stripe matching. One by one the photographs revealed that six of the tigers were an exact match to two litters in the old cub photos. The seventh cat appeared to be younger and probably a cousin.

Getting them released from WAO was complicated by the bankruptcy, but luckily the International Fund for Animal Welfare (IFAW) was

coordinating the placement of the animals as well as providing food to keep them alive during the process. Gail A'Brunzo from IFAW received approval from the judge to release the tigers and I asked Carole if she could take them.

When a sanctuary agrees to take a tiger they are agreeing to provide lifetime care for a cat that eats fifteen pounds of meat a day and requires specialized vet care and its own steel enclosure. Sanctuaries receive no government assistance and rely on donations to survive, so it is an enormous financial commitment for them to take one tiger. Carole agreed to take three. I now had to find a home for the remaining four.

Finding a home for a tiger is not an easy proposition to begin with, and I was warned that the New Jersey tigers would be difficult to place. They were old, very aggressive, and kept in the back of WAO with no exposure to anyone other than their keepers. Private owners or exhibitors would have no interest in these tigers. Zoos would not take them because they were generic (crossbred), and since they were bred in captivity and had no hunting skills they could not be reintroduced into the wild. They were just old tigers that nobody wanted to feed and that had no place to go.

The light in this dark story is that some people do care and have created sanctuaries for big cats—all I had to do was find another good one. A report on sanctuaries in the United States lists 130 with tigers. Unfortunately most of them are breeders, dealers, or unaccredited (roadside) zoos advertising themselves as sanctuaries but having no interest in providing lifetime care. To them the tiger is a commodity to be sold or displayed and then dumped when no longer of any commercial value. Only 20 of the 130 could be considered true sanctuaries. The closest one to New York was Carolina Tiger Rescue.

Asking an already full sanctuary to take in four tigers with no notice is best done in person. We went to North Carolina to meet Pam Fulk, who runs Carolina Tiger Rescue. Pam didn't have room but said that if we could get the tigers out of WAO she would keep them in her quarantine space until new enclosures could be built. She would take all four. An unexpected response to the impossible question, "Can you take more tigers?"

Transporting tigers, as I was about to find out, is anything but routine. The Hill Country outside San Antonio is dry to begin with, and a drought made it worse. Driving down the road to WAO we had to keep our car windows closed to avoid breathing the dust that seemed to be everywhere. The tiger enclosures were a combination of hard pan and broken rock, not a fit place for any animal.

The cats were apprehensive and could not be coached into the rolling cages so they had to be tranquilized (darted). By the time the last one (Marcus) was darted, the temperature was 95 degrees in the sun and there was no shade. Stress elevates the body temperature of a tiger. Their normal body temperature is 99.5; after darting Marcus's temperature got to 108. At that level he would be dead in half an hour. Cold towels were put on his face and head, and cold water poured on his body, and his temperature began to drop. He was put inside the transporter and given the recovery shot. After what felt like an eternity he moved his head and started to regain consciousness. A remarkable effort by Wild Animal Sanctuary founder Pat Craig and his son that saved Marcus's life. By 11:00 AM the rear doors of Pat's transporter closed and Marcus and company began their thirty-hour trip to North Carolina, stopping only for fuel and water for the cats.

Two weeks later I went back to San Antonio. This time the transportation was provided by JT and Laura Fletcher of Loving Friends Transport, and it was less eventful than the Carolina Tiger Rescue load. The two boys, Arthur and Andre, walked right into their rolling cages, but their sister Amanda was not going to go quietly. Once you see a very upset four-hundred-pound tiger inside a rolling cage you will quickly understand that you will do only what is agreeable to the cat. Ultimately Michelle, one of the WAO keepers, was able to quiet her down and get her inside the new transporter equipped with multiple air conditioning units. The tigers relaxed and began their twenty-four-hour trip to Tampa. After a few hours Amanda and her brothers were fast asleep. This trip was also nonstop with the exception of fuel and water for the cats. We flew to Tampa to watch Carole and Jamie release each tiger into its new enclosure. Seeing their paws touch grass was an unforgettable moment.

The fact that these original littermates have stayed together through difficult times and places is probably the reason they are still alive. This was a happy ending for this little family of tigers and the beginning of our journey into the world of tigers in America. We considered our search-and-rescue adventure an unusual convergence of events and were happy to be a part of it, but we would now go back to our regular lives in New York City.

And then the calls for help began—there are nine tigers in trouble in Ohio, there are tigers in trouble in Arkansas, Missouri, and Kansas. It is tough to say no when you know that if you do, that tiger will probably die in a bad place. So we said yes, and what started out as a one-off effort to save some old tigers in Texas grew into a nationwide tiger rescue project. WAO was not an isolated incident—it was a sample of what goes on every day in this country. There are more tigers in America than exist in the wild in the rest of the world.

WHERE DID ALL THE TIGERS COME FROM?

More questions led to more research that revealed that the seeds of the surplus tiger problem were sown in the 1960s by a series of seemingly unrelated events. The first occurred in 1960 when John Kluge, an American businessman, acquired a white tiger from India and presented it as a gift to the National Zoo in Washington, DC. After a visit to the White House to see President Eisenhower and a widely promoted tour of the country, the two-year-old white tiger, named Mohini, was a celebrity. Seeing the commercial potential of exhibiting tigers, especially white ones, the Cincinnati Zoo borrowed Mohini and began a breeding program to produce and sell white tigers to other zoos. Throughout the 1970s other zoos began to breed. It was no longer necessary to get tigers from animal dealers; now you could just breed your own. Tigers, especially white tigers, were great for attendance. Tiger breeding accelerated.

The second event occurred in 1967 in Las Vegas, when Siegfried and Roy began performing their magic show with big cats. Their timing was perfect: Las Vegas was transforming itself from a gambling den into a family-friendly entertainment destination. Siegfried and Roy were an immediate sensation, and every year everything got bigger—their audience, their show, and the size of their cat, from cheetah to leopard to the biggest cat, the tiger. They performed six days a week in front of sold-out audiences and became the highest-grossing act in the history of Las Vegas.

These events converged in 1983 when Roy was told about the white tigers and bought three from the Cincinnati Zoo. He and Siegfried incorporated them into the act and the tigers became their signature animal. Siegfried and Roy stopped performing in 2003 when Roy was mauled by one of the tigers. But during their thirty-five-year reign they performed in front of ten million people. Multiple generations of Americans no longer viewed the tiger as a beast to be tamed with a whip by a circus performer, but rather as a performing pet that one could walk on a leash.

Tiger popularity drove demand and white tigers were by far the most popular. While a regular tiger cub sold for $1,000, white cubs sold for $30,000. And any orange tiger with a white gene was immediately bought by a breeder.

In the wild, tigers breed once every three years, but in captivity breeders breed them three times a year, hoping to get a white cub. Throughout the 1980s and 1990s the breeding binge spilled out of the zoo network and into backyards across the country. People realized that there was no skill or experience needed to breed a tiger. You just put an adult pair in a barn, feed them road kill, and 109 days later you have a litter of three or four cubs. They are bred constantly because only one out of three hundred cubs is likely to be white; the rest are orange.

With this increased availability, live tiger exhibition moved beyond zoos and animal acts. Roadside zoos, usually limited to native species, multiplied. Now anyone could have a tiger. Phony sanctuaries added tigers. Anybody with a business—a winery, a bed and breakfast, a wedding venue, a gas station—could get one. Tiger breeding became a business in this country and the tiger became a disposable commodity. If your tiger died you could just go buy another one, with the additional benefit of being able to sell your dead tiger into the animal trade for parts. The tiger business has very little regulation and no meaningful

enforcement. Laws vary from state to state and many are overridden with a federal license to exhibit.

Because the requirement to register a tiger was eliminated in 1998, there is no way to accurately measure change in the tiger population, but we believe it is growing. Public interaction with tigers has become increasingly popular and very profitable, as cub-petting operators appear at state fairs, shopping malls, and fast-food parking lots. You can pet, hold, walk, run, or swim with a tiger for a fee. And since every phone is a camera you can record your experience and post it on Facebook, Instagram, and Twitter. Tiger selfies are the latest variation of these photo opportunities. And after the event, you go home and the tiger goes into a four-by-eight-foot cage, out of public view until the next event. What we have today is a perfect storm of tiger abuse—high demand, cheap supply, and no laws.

Exhibitor promotion has also become more effective. Live tiger exhibitions are done in the name of tiger conservation or education or preservation, with the appropriate number of signs and banners to convince you that you are contributing to the noble cause of saving the endangered tiger species. Tiger breeding has been going on for fifty years in this country and not one tiger has ever been introduced into the wild.

SO WHAT CAN WE DO?

We began with three assumptions:

1. The big exhibitors, circuses, and theme and safari parks will resist any change that endangers their supply of cheap tigers, so breeding will not go to zero anytime soon.
2. Most zoos will continue to dump their old tigers.
3. We will always need the sanctuaries to be a home for unwanted tigers that would otherwise die from neglect or from being shot outright.

Our conclusion: If breeding can be reduced and sanctuary capacity increased we can get to a point where there will be fewer unwanted tigers and those in need will always have a home. And the killing will stop. It will take awareness and sanctuaries to make this happen.

Awareness: Ninety percent of the general public is unaware of the breeding and abuse. When they become aware they will avoid the live tiger exhibitions and photo opportunities. The exhibitions will stop when the money stops.

Awareness can also fuel advocacy to pass regulations for standards of care. The cost of proper care will reduce profits and marginal facilities will close.

Sanctuaries: Established sanctuaries already have the property, staff, food source, keepers, and vet care necessary to care for the tigers. Their primary impediment to growth is their number of tiger enclosures. The more spaces they have, the more tigers they save. Increasing the number of enclosures provides immediate relief in two ways.

First, there are a number of private owners who acquired a big cat without realizing the amount of care it would need, and who are now in a situation where they still love their tiger but are no longer able to care for it. They do not want to kill it or dump it into the dealer system but they will surrender it to a reputable sanctuary.

The second benefit involves law enforcement. There are three thousand roadside zoos in forty-four states. They are located in rural communities down the road from shopping malls and schools. Many of them keep tigers in substandard conditions with inadequate fencing. In almost all cases the local sheriff is aware of the facility and its danger, either directly or from neighbors' complaints, but is reluctant to shut it down. There is no place for him to send the cats and he does not want to appear on the six o'clock news and explain that he had to kill the tigers because he couldn't find a zoo to take them. In far too many communities the sheriff's strategy is to "hope the tigers die before they get out and kill somebody." Additional sanctuary capacity will allow the sheriffs to deal with the threat before someone is hurt or killed and it becomes a public relations nightmare.

In almost all cases when the cat gets out it will be killed. In 2011 the sheriff of Zanesville, Ohio, had to kill eighteen tigers and seventeen lions because their owner let them loose in the small community.

We live in the most prosperous and philanthropic nation in the world. It is not unreasonable to expect that there are organizations already doing something about this problem. Tiger abuse has been going on in this country since 1833 when Isaac Van Amburgh went inside a tiger's cage and beat it with a pipe to get it to perform, and so became our first tiger circus act. The difference now is the size and depth of the breeding business and the number of tigers at risk.

We found organizations—the Humane Society of the United States, IFAW, Born Free, and sanctuaries including Big Cat Rescue, PAWS, and the Wildcat Sanctuary—actively engaged and doing exceptional work to get the issue out into the general public and in front of legislators.

The top twenty wildlife charities headquartered in the United States raise $700 million every year to save tigers in the wild, but they provide no help for tiger sanctuaries in this country.

There are people like Bob Barker, who provide amazing support for true sanctuaries, but for the most part the sanctuaries are left to find their own donors. And in the process they must compete with phony sanctuaries that are soliciting for the same cause. As for the question of who actually cares for the tigers in this country, we found thirteen true sanctuaries that care for 420 tigers, more than all the tigers in the 115 AZA (Association of Zoos and Aquariums) zoos in North America. We formed and funded Tigers in America to rescue tigers, transport them to these sanctuaries, and help the sanctuaries build enclosures.

Identifying true sanctuaries was a bit of a challenge because there is no restriction on the use of the word "sanctuary" in a corporate title, so anyone can form a legal entity, call it a sanctuary, and then file for and receive tax-exempt status from the IRS and begin fundraising. After two years of traveling and talking to sanctuaries we compiled a list of those we consider to be the best in this country. The Exotic Feline Rescue Center (EFRC) is a prominent name on the list, and was one of the earliest, not only for the passion and drive of its founder Joe Taft but for the dedication of Rebecca Rizzo and the EFRC staff and volunteers and the quality of care they provide. EFRC happens to be the largest of the Tigers in America sanctuaries, as measured by the number of tigers in their care.

We first learned about Joe from his appearance in the documentary film *The Tiger Next Door* and from a subsequent conversation we had with the filmmaker, Camilla Calamandrei, and mystery writer Michael Koryta. On our first visit to EFRC we were met by Joe and given a tour. About fifteen minutes into the tour we stopped in front of an enclosure, and three feet away, staring back at me, was one of the most striking tigers I have ever seen. The sun reflected his gold and white stripes. His name was Sahib, and he was one of the two brothers we knew from New Jersey. EFRC was one of the first sanctuaries to take cats when WAO failed, and among the tigers Joe took were the brothers. Unfortunately Sultan had died, but there stood his brother, looking straight at me seventeen years later.

He was one of the reasons I formed Tigers in America.

Bill Nimmo,
founder of Tigers in America

Acknowledgments

Several people had asked about a new book, but producing a third book about felid rescues was not a happy thought. Sarah Jacobi at Indiana University Press changed my mind. Without her enthusiasm, and the giant poster of the second book outside her office, this book would not exist.

EFRC keepers Rebecca Rizzo, Jennifer Hall-Lamb, Shaina Cranson, Christina McCrea, Jessica Phillips, and Kerry Lennartz tolerated my questions, repeatedly. It's amazing that the keepers can identify a tiger by a quick glance at its stripes.

My partner Caryl Antalis tolerated looking at photos, reading Joe's stories, and making corrections, and kept smiling.

Stephen D. McCloud

EFRC keepers, January 2015

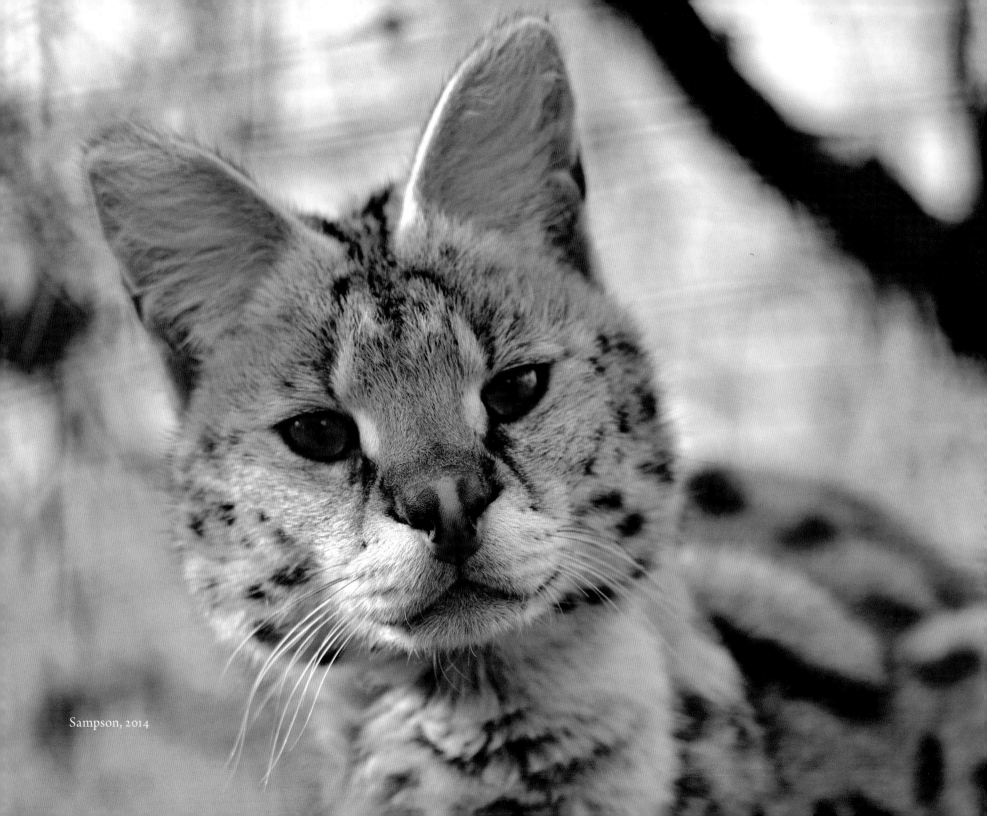

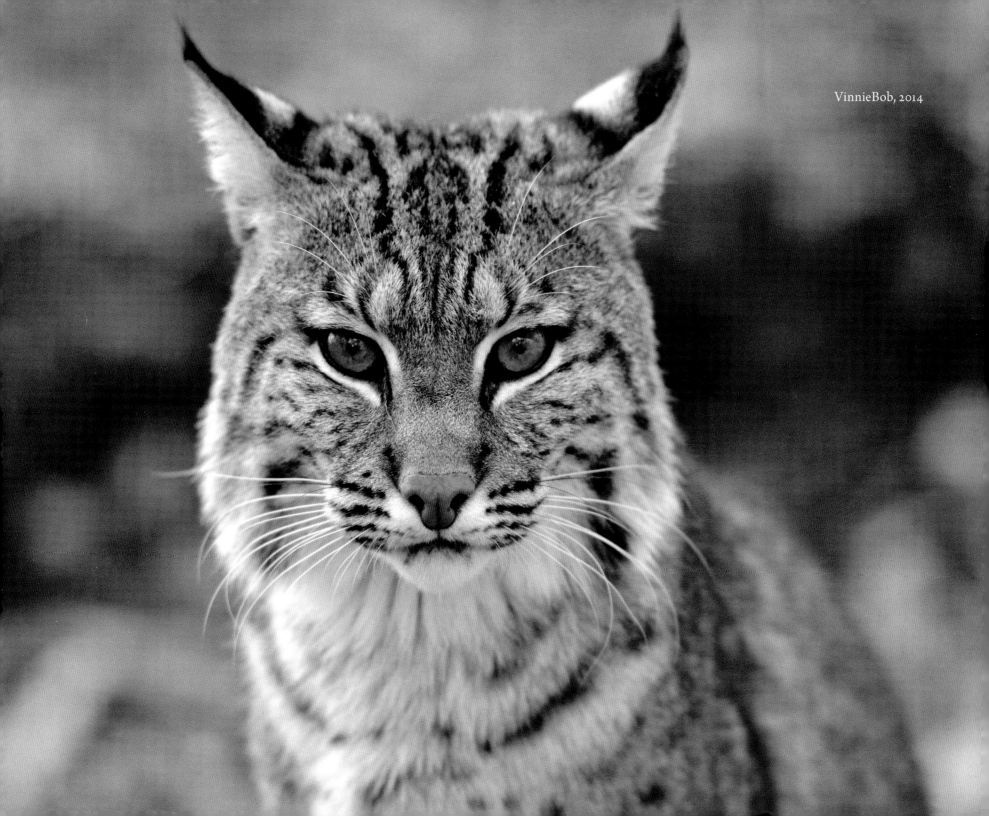

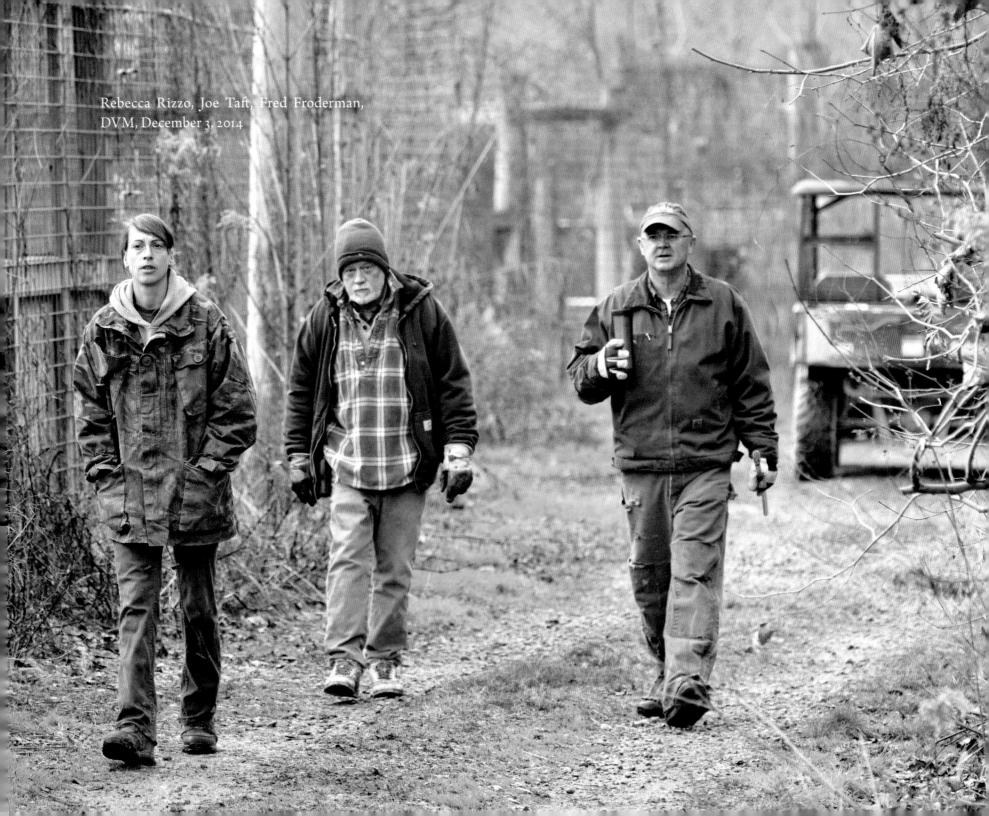

Rebecca Rizzo, Joe Taft, Fred Froderman,
DVM, December 3, 2014

The Origins of EFRC

Joe Taft was twenty years old when he walked into a pet shop in Terre Haute, Indiana, and bought an ocelot. Although today Joe strongly disapproves of exotic pet ownership, his fantasy at the time was to drive around fast in a Lotus with a cheetah in the seat beside him. He settled for an MG and an ocelot.

After college, Joe eventually moved onto six acres in New Mexico, where he acquired a one-year-old female leopard. Taaka, as he named her, lived with him as a house pet. She had a large outdoor area and the run of the house for nearly nineteen years. Shortly after Taaka's death, Joe bought a thirteen-day-old leopard he named Kiki.

Joe Taft, June 15, 2013

When Kiki was about six months old, Joe happened across a couple of badly abused tigers, BC and Molly. This was his first experience with the mistreatment of exotic felines, and he was outraged. He rescued the two cats—and thus began the effort behind the Exotic Feline Rescue Center.

In 1991, Joe left New Mexico and returned to Indiana with Kiki, Molly, and BC. He looked for a piece of land where he would have no immediate neighbors. The fifteen acres he purchased are now the portion of EFRC open to visitors. The nonprofit corporation that was subsequently formed to support the center purchased another eleven acres. Someone later donated money to purchase eighty-two additional acres on the south side of the road.

"If you build it, they will come"—and come they did. Soon someone called and asked whether Joe could take a lion. Then someone else called, hoping that he could take another unwanted feline. Suddenly there were five lions. Then a puma. Then a bobcat. Then many, many more. All were taken on a permanent basis. When a big cat finds its way to the Exotic Feline Rescue Center, it has a home for life.

One of the most frequently asked questions by new visitors to EFRC is, "Where do these animals come from?" The usual answer is circuses, zoos, breeders, and people who had them as pets. Sometimes animals arrive singly. At other times they come by the truckload. That was the case in the summer of 2000, when the center added a large group of exotic felines from one of the worst facilities ever discovered. On August 21 of that year, EFRC workers traveled to Pittsburgh, Pennsylvania, intending to return with two or three lions, which they hoped to introduce to a group of young lions already living at the center. When they arrived at the facility, they found neglect and abuse beyond belief. In a dark basement

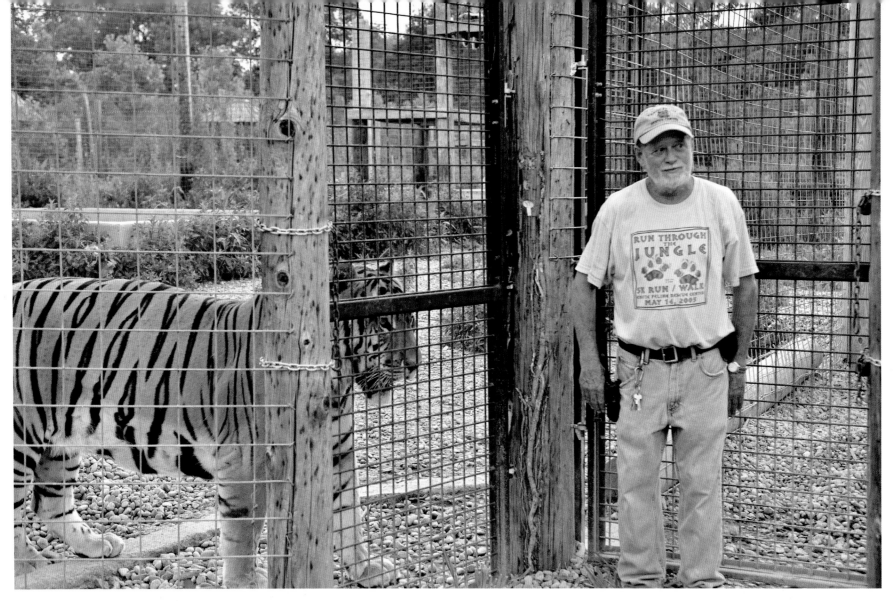

Joe Taft with tiger, June 21, 2014

that reeked of feline urine and feces were four cages about five feet by five feet. There were three lions in one cage, three tigers in a second cage, and one tiger each in the other two cages. Seven of the cats were severely malnourished and dehydrated. They apparently had been left to die. They weighed 50 to 80 pounds instead of the 200 to 250 pounds that a healthy lion or tiger their age should weigh. The eighth was closer to normal size but still substantially underweight. Fearing that none of these felines would survive, EFRC workers loaded all of them into a truck and headed for Indiana. It was the first time in a long time that the animals had seen sunlight or breathed fresh air.

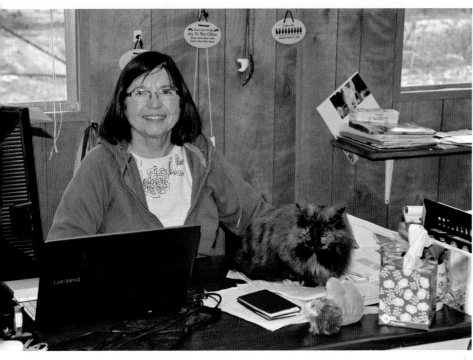

Jean Herrberg and Roxie, December 10, 2014

There are many other "rescue centers." Few, however, come up to the standards of EFRC. Some visitors come expecting to see a zoo. When was the last time you saw a blind tiger at a zoo? Or a Canada lynx with a neurological problem? Or a puma with frostbitten ears? Zoos want, and more importantly keep, only "perfect" animals. Whereas zoos are concerned with species survival and displaying animals in cages for the benefit of humans, EFRC is concerned with individual survival.

When EFRC was incorporated in 1996, there were only about twenty animals housed at the facility, and all the work was done by volunteers. In 2015 there are over two hundred exotic felines at EFRC, and a board of directors oversees a budget of more than $700,000. Joe has full-time employees but the center's volunteers still play an essential role.

Jean Herrberg is the assistant director of EFRC. Sometime in the mid-1990s, she started coming to the center as a volunteer. She arrived just in time to hand-raise two baby lions, Spirit and Parker. After traveling back and forth to her teaching job in Columbus, Indiana, Jean decided to retire from teaching and move to Center Point—her original home, where she still had family. Jean spends much of her time traveling around the country picking up animals, doing educational programs, answering mail, and fundraising.

After one lion died during minor surgery at the office of a local veterinarian, the EFRC staff started taking animals to the University of Illinois—a two-hundred-mile round trip. In 2004, a new building was established at the center with space for a complete hospital. Most surgeries are now performed on the grounds.

When Joe Taft rescued BC and Molly all those years ago, little did he know where his act of kindness would lead. With the help of dedicated staff and volunteers and the generosity of donors who share Joe's passion for these big cats, the Exotic Feline Rescue Center has been able to expand its mission: to give these special animals a dignified life in a permanent home with the best of care. In 2016 the Exotic Feline Rescue Center will celebrate its twenty-fifth anniversary.

Stephen D. McCloud

Two weeks later, a semi pulled up at EFRC. In it were eight more lions and tigers that had been seized by the US Department of Agriculture from the same person in Pennsylvania. After years of citations for violations of the Animal Welfare Act, fines in 1997 and 1998 totaling $32,000, and revocation of the owner's license, this facility had finally been closed.

Another tiger that had been rescued in Pennsylvania by the USDA was initially placed at a rescue center in Mississippi. He became extremely aggressive there, injuring his cagemate and human staff, so on September 9 he too was transferred to EFRC. He settled in nicely and has become a favorite of most of the workers. Maybe it's the name Felix, or maybe it's because of his friendly behavior. He never has an unkind word for anyone. He loves his new life and seems to have completely forgotten the abuse he suffered in the past.

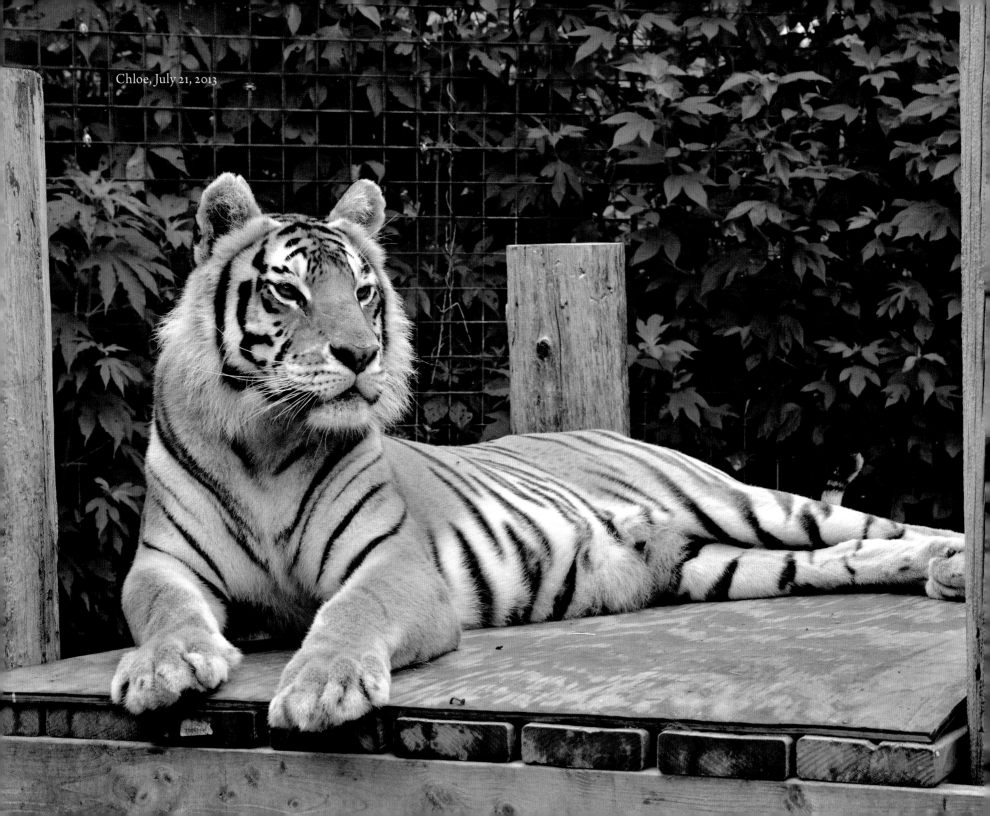
Chloe, July 21, 2013

Athena, Barbie, Chloe, and Nemo

The Lakewood Zoo in Wisconsin had been closed for quite a while. All of the animals had been placed except for four tigers. Alerted to this situation by members of the Feline Conservation Federation, and after phone calls from municipal officials, EFRC staff left the sunshine of Indiana and headed for the snow of Wisconsin.

They arrived in the late afternoon but were able to go to the zoo and see the tigers to assess the situation. The tigers all appeared healthy and well fed. Two tigers—Chloe, a female, and Nemo, a male—lived together. The other two female tigers, Athena and Barbie, lived alone. While the

Bailey, September 19, 2013

tigers looked good, the general situation did not. The staff were surprised by the amount of snow and ice, but they were prepared. While they could not get their truck or cages close to the existing cages, they were able to set up in a cleared parking lot. The owner fortunately had a four-wheel-drive truck to help navigate this situation. All four tigers were immobilized, were given a quick physical exam, were vaccinated, had blood drawn, and were given three liters of warmed subcutaneous fluids. The tigers were then moved into the owner's truck and then to the EFRC truck. The tigers were covered with straw to keep them warm. Then came the seven-hour return drive, much of it through blinding rain.

Cages at EFRC had been prepared and three of the tigers were moved right into their new enclosures. Athena was considered a security risk and was kept in her transport cage in the meat processing building while an empty cage was topped. Within days all of the tigers were out and doing well. A few weeks later, staff noticed that Chloe had gained some weight in certain areas of her body. After several weeks when her physical appearance didn't change it was decided this must be a false pregnancy. Wrong! On June 22 she gave birth to five female cubs: Bailey, Claire, Koala, Kizmin, and Munka.

Chloe was a very good mother. She did everything right and didn't mind staff monitoring the cubs on a regular basis. Three of the cubs were about the same size, while Bailey was the runt and Claire was much larger. Then on August 7 it was obvious that Bailey had taken a downward turn. Staff pulled her and started feeding her around the clock with formula and other dietary supplements. In four days she was making a terrific comeback. Three weeks later Chloe developed mastitis and her production of milk took a nosedive. All of the cubs were pulled and put on an all-meat diet.

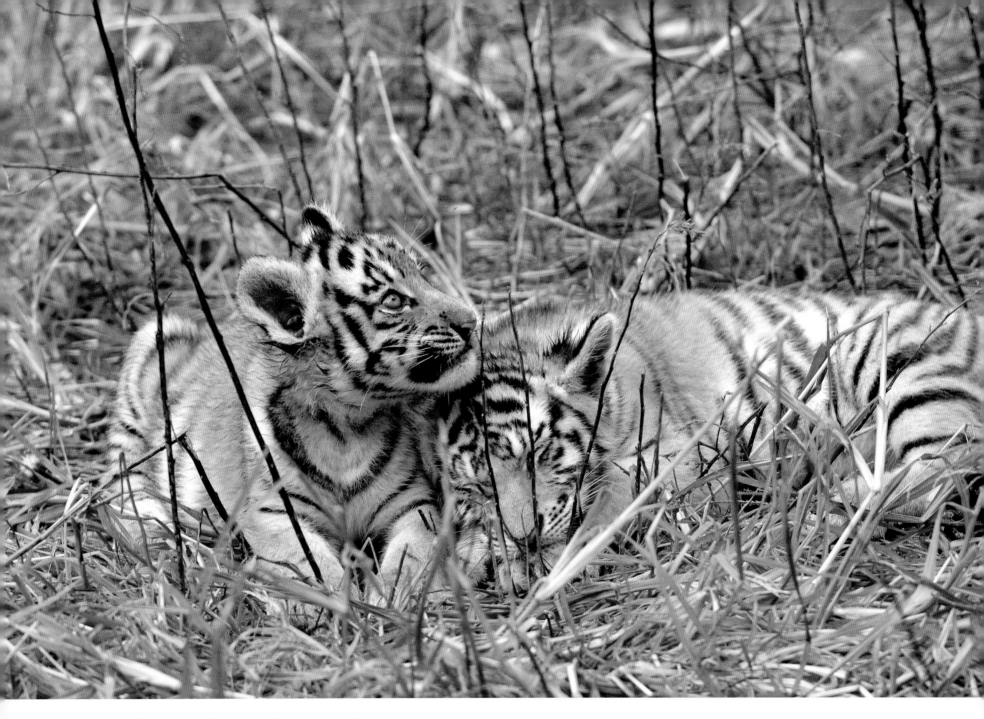

Bailey and Claire, September 19, 2013 *(above and facing)*

8

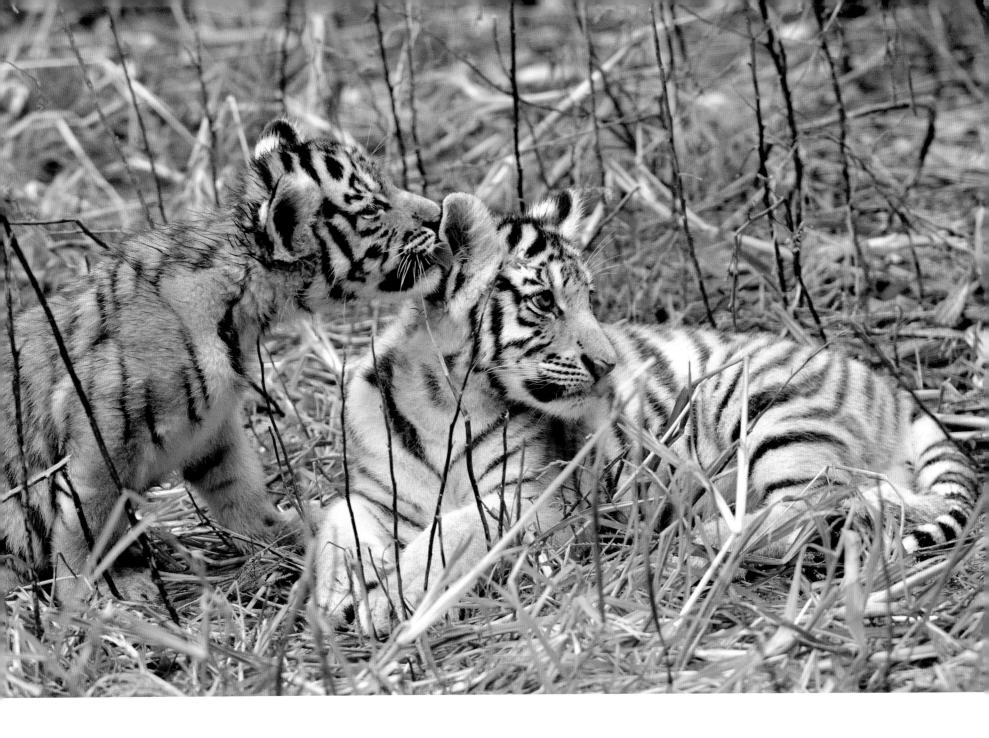

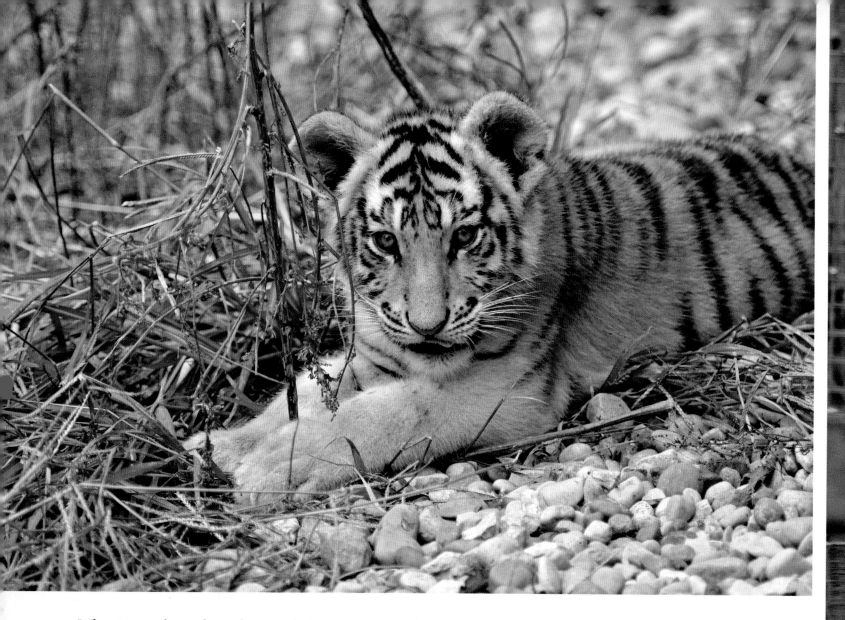

When tiger cubs are born they weigh about 2 to 3 pounds, at three months they are about 30 pounds, at one year they will be about 200 pounds, and as adults 300 to 600 pounds. The cubs will probably be about 350 to 400 pounds when fully grown.

After more than two years, all five of Chloe's cubs are still living together and getting along better than anyone expected.

Munka, September 20, 2013

Kizmin, March 25, 2015

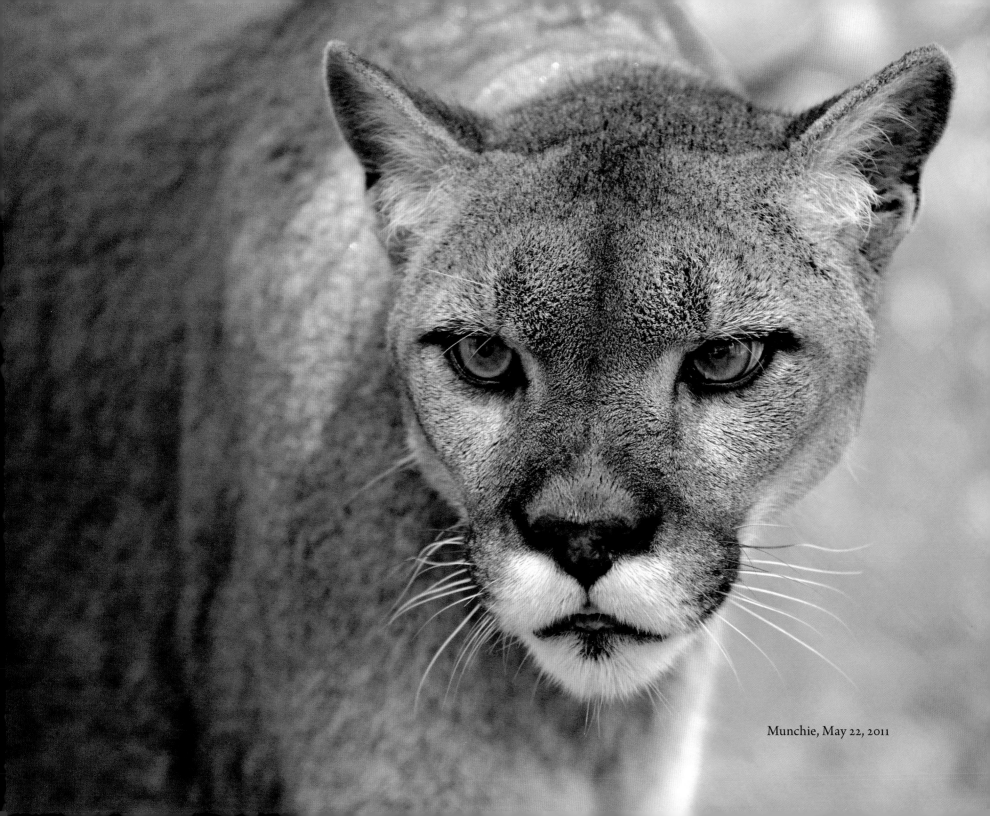

Munchie, May 22, 2011

Blackie, Munchie, and Rajah

A male leopard named Blackie, a female puma named Munchie, and a male tiger named Rajah arrived at EFRC from the William Sheperd Wild Animal Orphanage in Uniontown, Pennsylvania. Blackie had been rescued by Dr. Sheperd in a federal seizure in Ohio in 2004, while Munchie had been rescued in a federal seizure involving Water Wheel Exotics in Pittsburgh, Pennsylvania, in 1999–2000. Dr. Sheperd had rescued many animals but had reached his limit on the number he could care for. EFRC had previously worked with Dr. Sheperd during the rescue of the Munchkins, a group of lions and tigers that were starving when taken in by EFRC.

Upon arrival at EFRC, Blackie was diagnosed with allergic dermatitis. He was treated and his condition improved greatly. The initial veterinary examination stated, "The hair on the ventral trunk is thin and there are poorly defined patches of mild to moderate hyperpigmentation ± mild lichenification. On the neck and shoulders and to a lesser extent the head there are patches of alopecia up to 1.5 cm in diameter that are associated with thick, moderately hyperpigmented and mildly scaly skin. Around the eyes extending to the dorsum of the muzzle and to a lesser extent the lips there is alopecic, hyperpigmented, thick and shiny skin that is reminiscent of deep pyoderma. These areas were not particularly friable." In other words, Blackie had a lot of hairless patches and scaly skin.

Black leopards are what some people call "black panthers." Black leopards are not black and there is no such thing as a panther. Black leopards have brown skin with black spots. The term "panther," these days, can refer to leopards, pumas, and just about any cat that size. If someone says they saw a panther, it is impossible to know what they have seen.

During one of EFRC's annual "Pumpkin Parties," Blackie seemed to have eaten all of his pumpkin. Felids play with the pumpkins after eating all of the chicken placed inside them, but they are not known to eat the pumpkin.

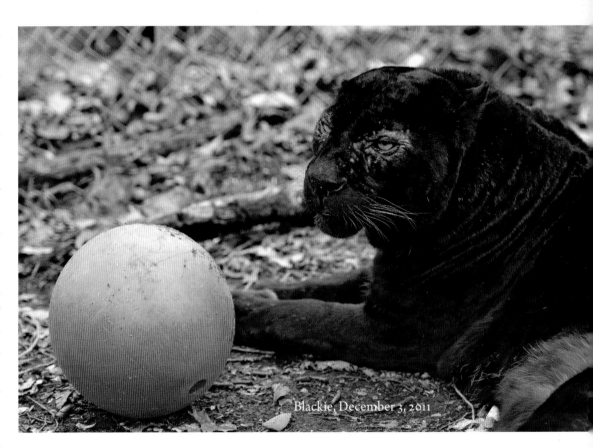

Blackie, December 3, 2011

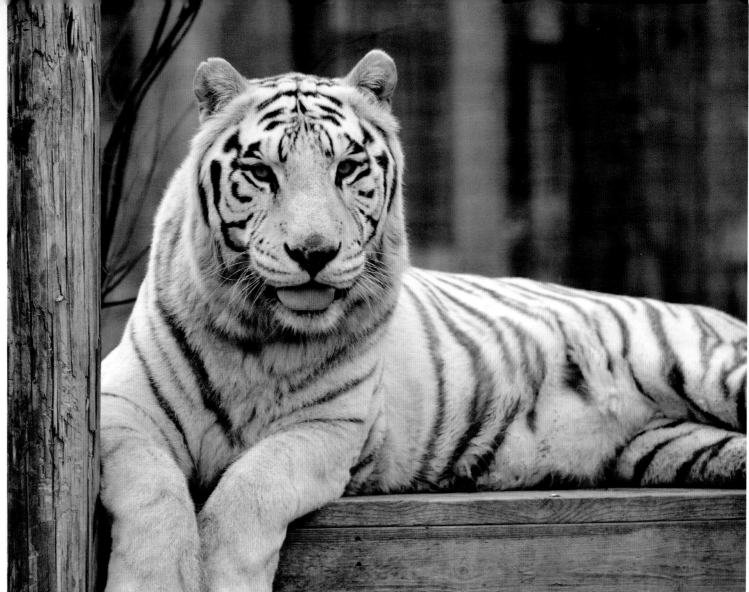

Rajah, November 30, 2014

Rajah, August 11, 2012

15

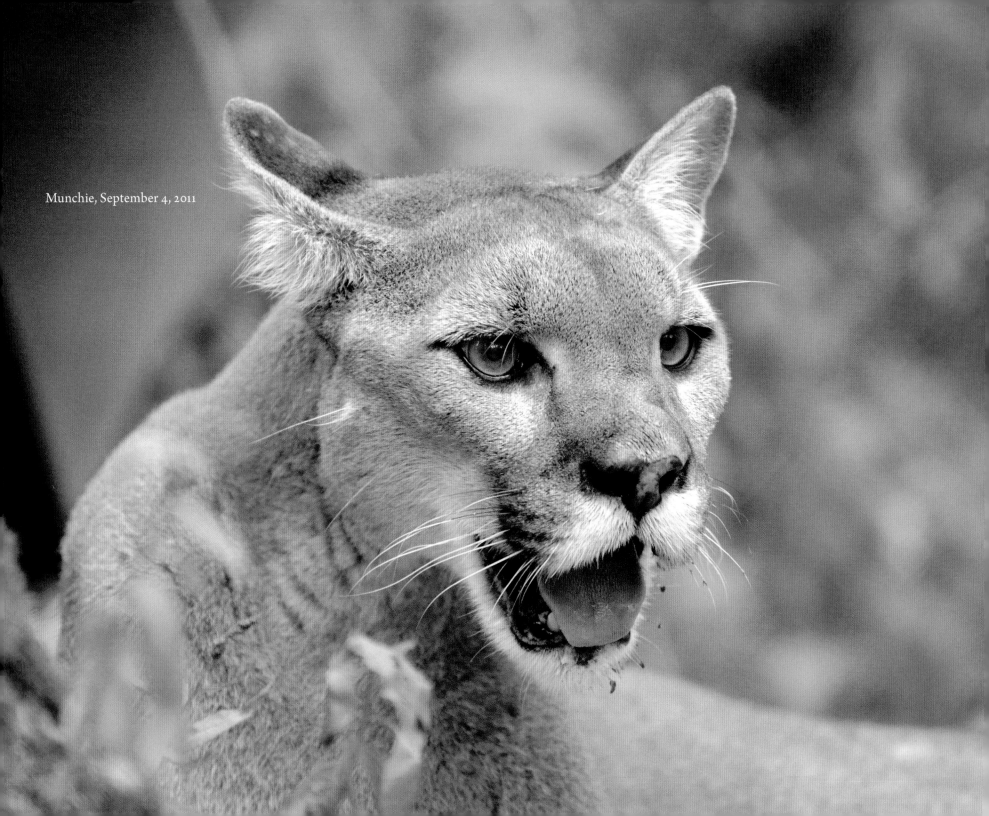

Munchie, September 4, 2011

Boi Pello

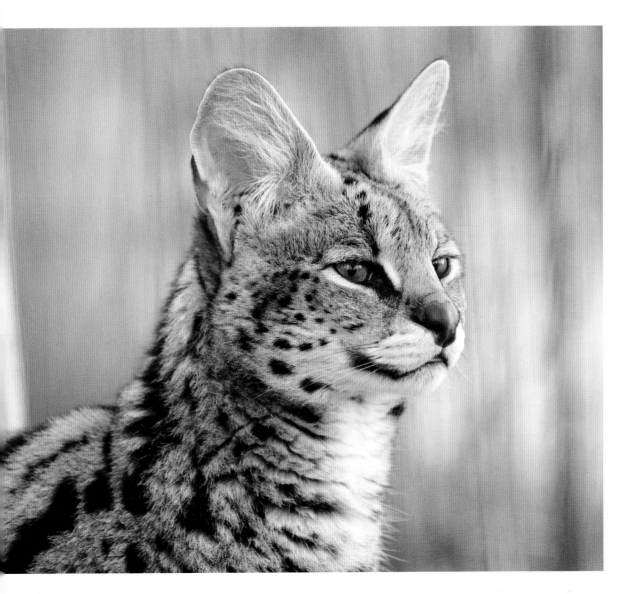

In late 2003 Boi Pello, a male serval, was confiscated by the Connecticut Department of Environmental Protection from an owner in Voluntown, Connecticut. Connecticut laws prohibit private ownership of servals.

Boi Pello was transferred to Beardsley Zoo in Bridgeport, Connecticut, in early 2004 for temporary holding. He appeared to be in good condition and had been castrated and declawed prior to his arrival at the zoo. His weight was listed as thirty pounds. From the zoo's behavioral history: "Interested / intelligent / wants to play—hisses when uncertain who you are / bringing in new items / or just not 'happy.' Other times does fine—will hiss if taking too long to give him the enrichment food." From the other zoo descriptions, Boi Pello appeared to be very happy and playful.

In April 2004 Boi Pello was transported to his permanent home at EFRC, where he eventually shared his enclosure with two other servals. Like most servals at EFRC, Boi Pello greets visitors with a snake hiss. The three servals are at the start of the main tour.

Boi Pello, December 5, 2009

Bonnie, October 2, 2010

Bonnie, Charm, Copper, Jade Jr., Kennedy, Killer, Lincoln, Mickey, Neko, and Temple

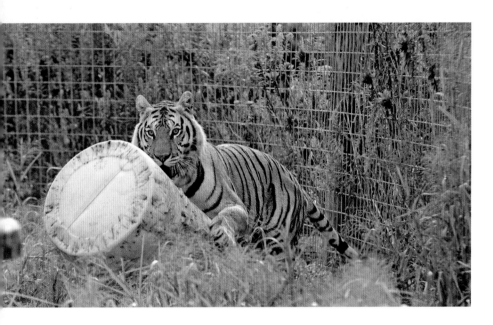
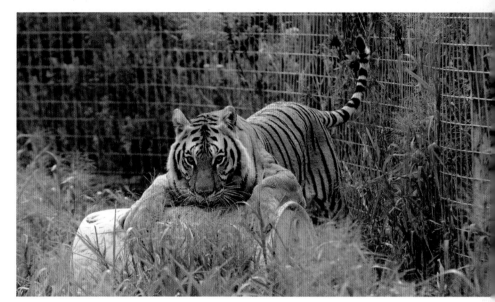

Charm, September 10, 2011 *(left and right)*

Ten tigers from an Oklahoma traveling animal show, three of whom were involved in the 2003 death of a young woman, were rescued in early November 2009: seven males (Copper, Kennedy, Killer, Lincoln, Mickey, Neko, and Temple) and three females (Bonnie, Charm, and Jade Jr.). According to a USDA document, the animal show was closed by federal authorities after the "extraordinarily hungry" tigers, who had not been fed for four days, "ripped off and carried away her arm" in a "feeding-like frenzy" when they reached through an eight-inch opening in the cage.

After weeks of preparation, two EFRC staff members set off for Oklahoma accompanying a leased semi truck. Arriving in Oklahoma they found ten hungry and thin tigers living in nine-by-fourteen-foot cages in a barn. EFRC had originally agreed to take eleven tigers, however, one of them mysteriously disappeared or died suddenly before EFRC arrived. Their former owner gave them up voluntarily after losing all of his federal permits, facing opposition from local law enforcement and neighbors, and being evicted from the property.

Again the animals appeared not to have been fed for several days. They were loaded without incident and began their fourteen-hour journey to their new home at EFRC. Housed temporarily in the meat processing building where they were continually fed, all the tigers gained weight. Mickey, the white tiger, is cross-eyed. Temple had obvious difficulties walking and maintaining his balance. The ten tigers comprised three social groups and two single, noncompatible individuals. Five permanent enclosures were needed, costing thousands of dollars.

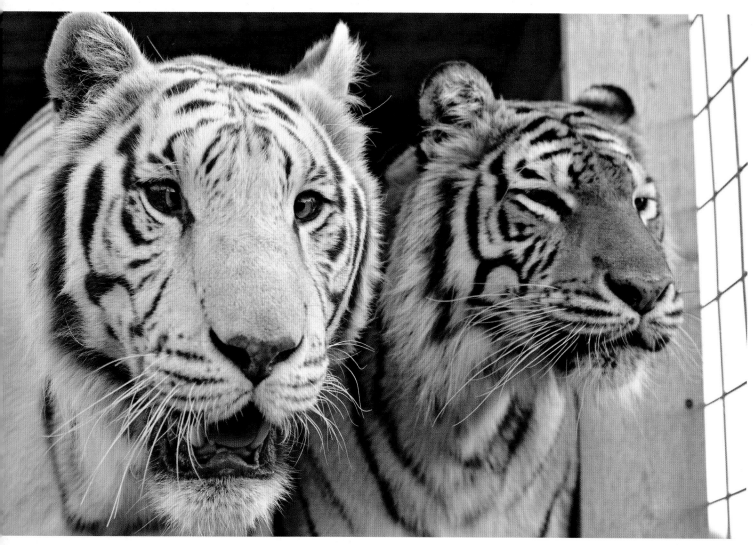

Mickey and Bonnie, August 11, 2012

Because of their inbreeding, white tigers can have "interest-ing" personalities, and Mickey is no exception. He's fond of plastic barrels and gets frustrated when the barrel won't fit through the door between the large area and the shelter area of his cage. His two female cagemates seem to be fond of him.

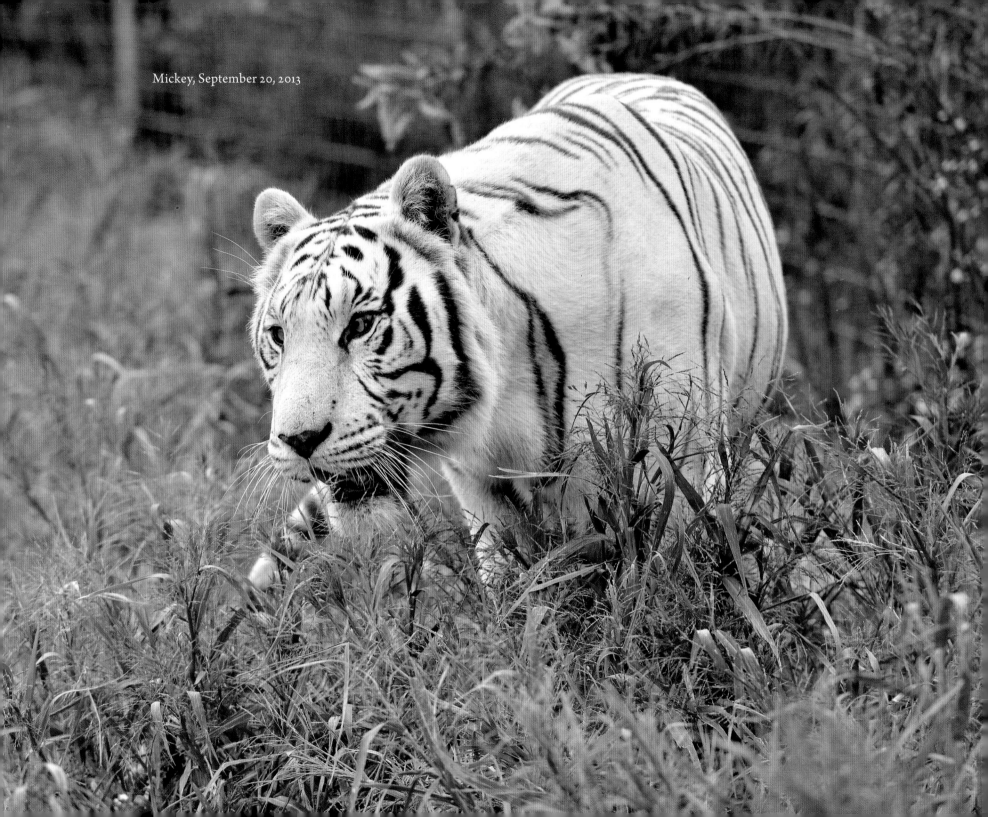

Mickey, September 20, 2013

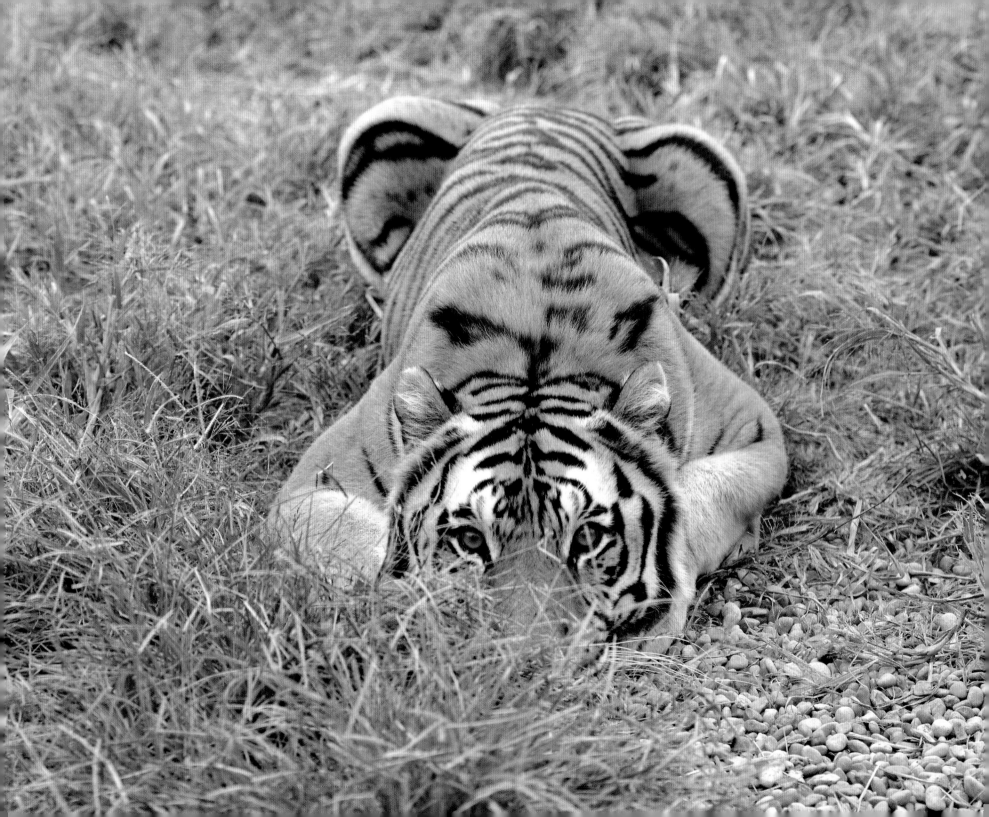

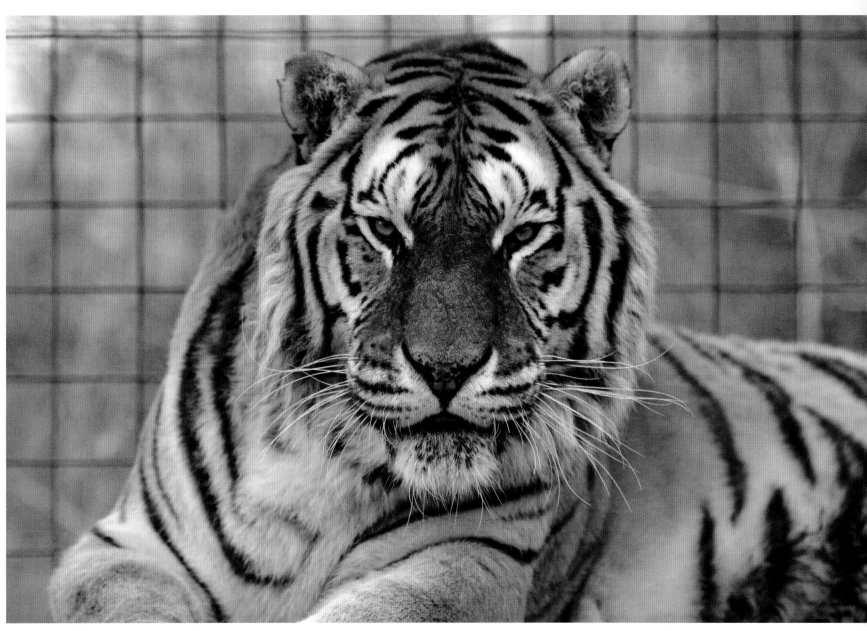

Killer, December 23, 2014

Temple, September 20, 2013

23

Buddy, Cash, and Tango

These three male tigers arrived at EFRC in May 2011. Buddy is the father of Tango and Cash.

The tigers had lived at Fun Spot Amusement Park & Zoo in Angola, Indiana. Fun Spot had fallen on hard times and was forced to close. Some of the rides were sold off; others went as scrap metal. When EFRC staff arrived they saw an abandoned roller coaster and a Ferris wheel stripped of its seating.

Making this trip to Fun Spot from EFRC, in addition to Joe Taft, were volunteer Michael Koryta, head keeper Rebecca Rizzo, keeper Jennifer Hall-Lamb, volunteers Larry and Rosie Lewis, and volunteer John Schopp. The group made the trip in two days and covered one thousand miles.

The cages at Fun Spot were far superior to what rescue crews usually encounter, but nothing near what the cats would find at EFRC. Judy Sharpe, who cared for the cats for years said, "They're going to the Hyatt."

Food was offered as a bribe and Tango and Buddy boarded the old circus cages used as transport cages. Cash was not as cooperative but eventually loaded. Unloading at EFRC almost went as planned. Buddy and Tango easily entered their new home. On the trip to EFRC Cash decided the old circus cage was his favorite place and refused to leave. After every effort was made, Cash was left to ponder his situation. The next day he decided to join the other tigers.

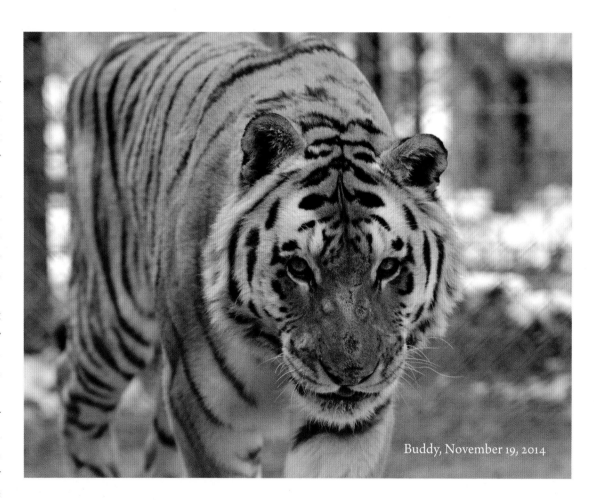

Buddy, November 19, 2014

Because the three tigers were not getting along it was necessary to separate them. As of January 2015 they were on the main EFRC tour in separate cages.

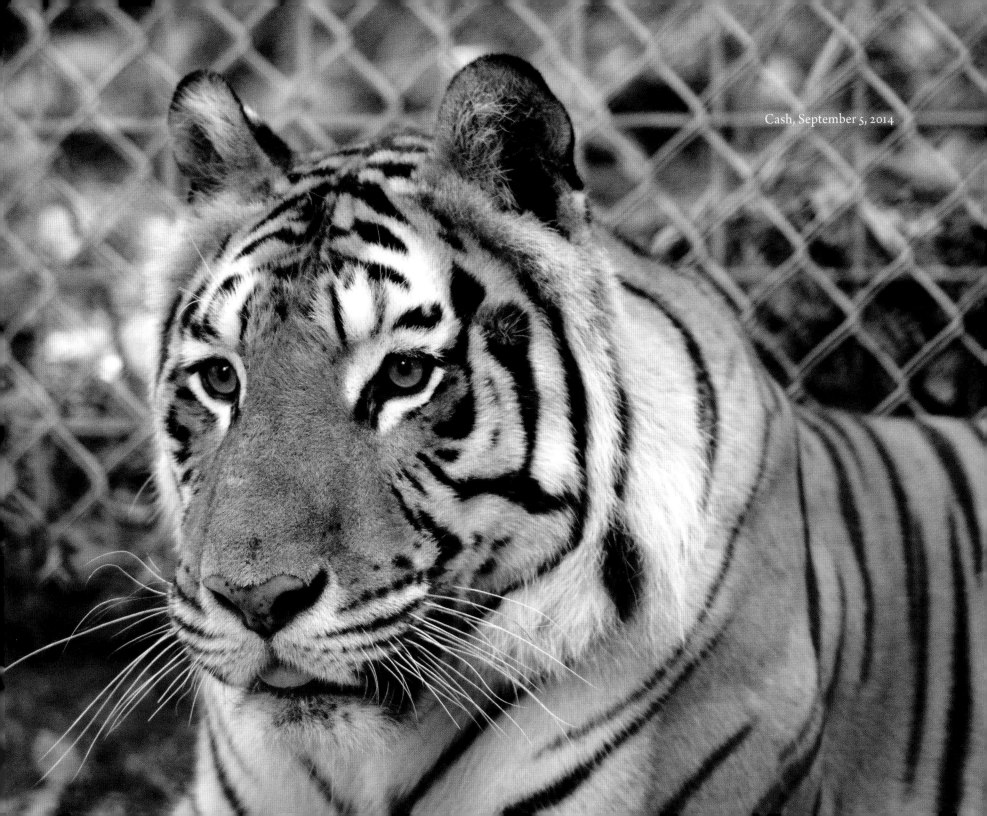

Cash, September 5, 2014

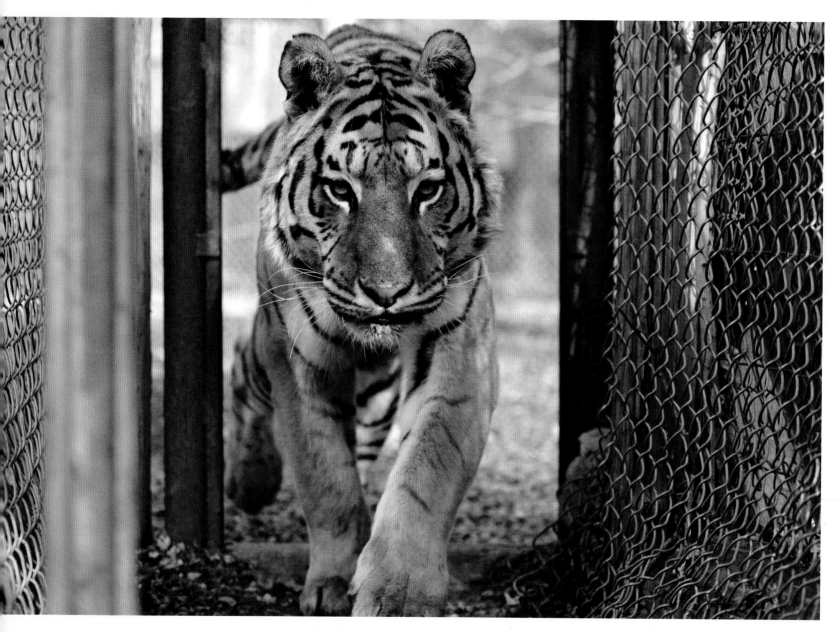

Tango, December 3, 2014

Tango, December 9, 2014

26

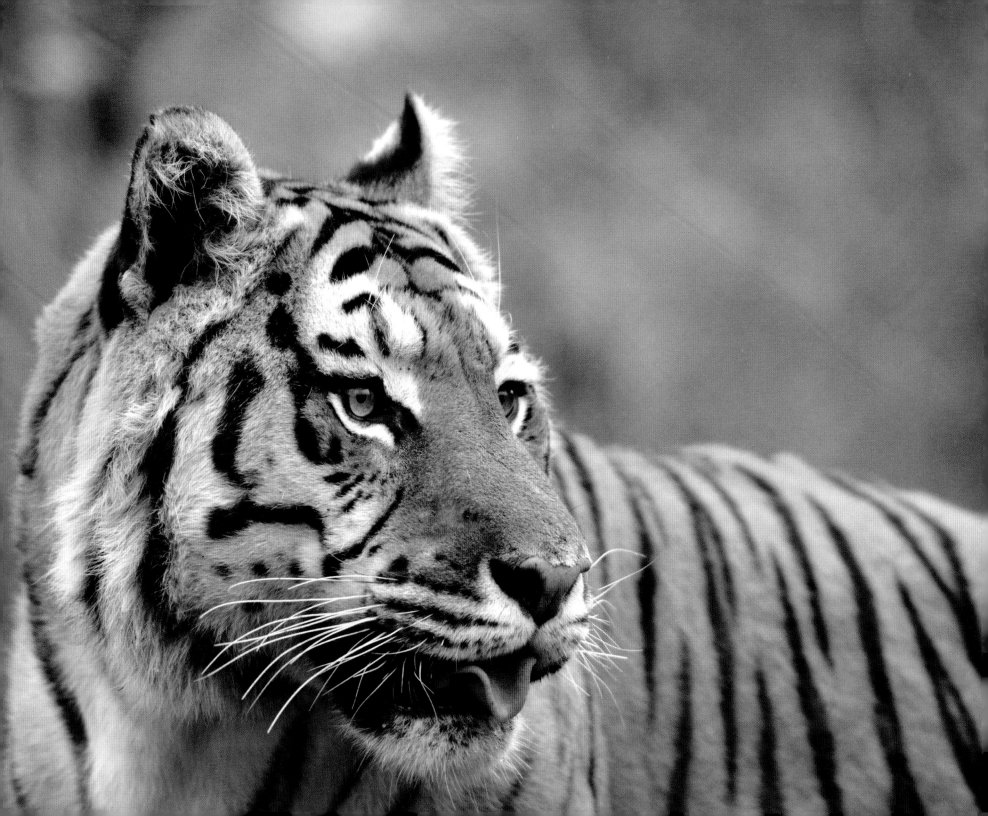

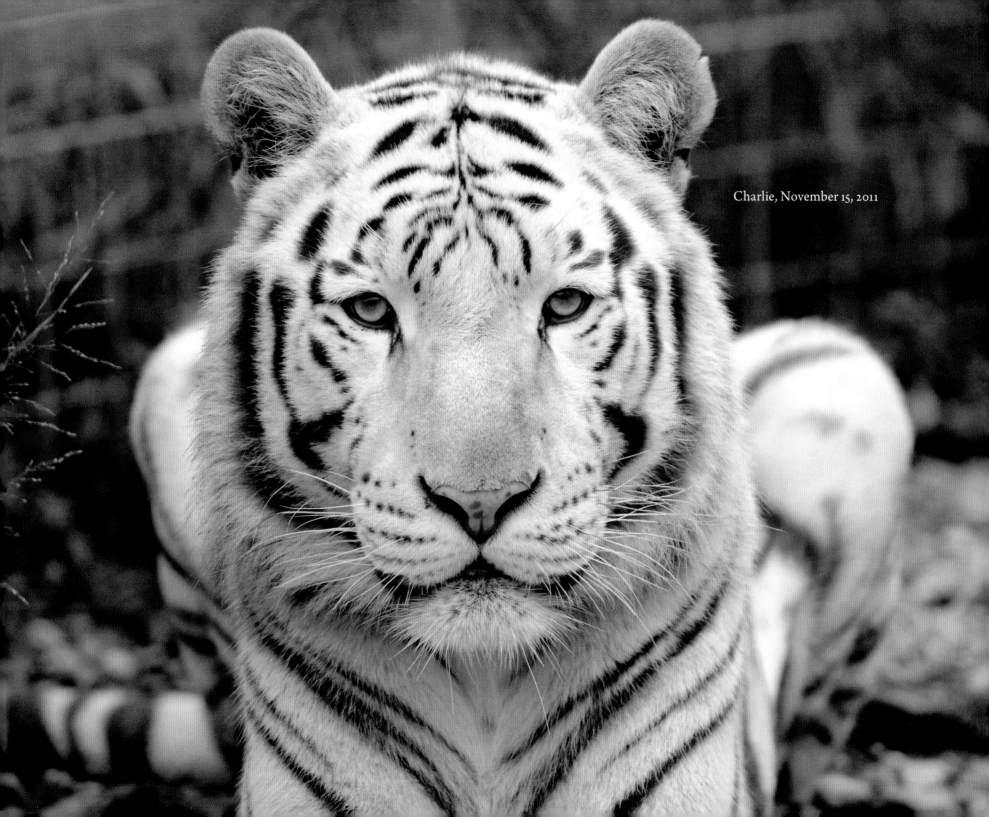
Charlie, November 15, 2011

Charlie

One of the most important things in a rescue is getting a veterinary report as soon as possible. Charlie, a male tiger, arrived at EFRC barely able to walk, and he had swollen feet and sores on his paws. He had been in this condition for several months before he was confiscated by the USDA, and had been housed in a small concrete enclosure with no access to the outdoors.

What follows are excerpts from a vet report made at the time he was confiscated. Charlie improved quickly at EFRC and even learned to run.

Birth: 19 May 2005 (Estimated)

Clinical Note: Confiscation: This cat was confiscated by USDA due to severe lameness of six months duration from Kirby's Magical Show in Branson, MO. Noted that the lameness had been the left rear foot and now lame on both left front and rear legs. Asked by USDA to confiscate and hold cat for five days and then to be transferred to large cat sanctuary in Indiana. Cat was held in a 10 × 10 foot concrete enclosure—a wooden hide-a-box was provided. The fence was a 2 × 4 horse panel. Flooring was clean but all concrete. Fluorescent lighting only. No outdoor access and no different ocular or nasal discharge. Mucous membranes are pink and appear moist. Eyes are bright and clear. When ambulating, the left front foot is completely non-weight-bearing. The left rear foot also showed lameness.

Assessment: Stable enough for immobilization and transport to hospital.

The left rear pad has a large deep ulcer present on digit 4. The right foot does not have any gross lesions on the pads, however, foot appears slightly swollen. Blood was collected from the saphenous vein for CBC, chemistry, and banking. . . . Carried using cargo net to lion restraint in trailer. Placed inside and given straw to padding. . . . Still very light and sound responsive—most likely from ketamine still in system. Calmed after about 15 minutes. Transportation back to hospital was uneventful. Did have some diarrhea in cage and smeared on his caudal thighs. Used bobcat to lift and place into

Charlie, September 4, 2011

isolation cage—very stressed (panting and drooling). Lifted cage doors for access to concrete outdoor holding and inside holding. Laid in cage for one hour without moving. Finally got up with stimulation—very painful on front leg and very stiff. Went inside and laid down immediately. Did not want to get up. . . . Plan to immobilize Tuesday when getting ready to load for transport to sanctuary. Blood was submitted [to] Emergency Animal Clinic for CBC/chemistry.

Charlie is on the main tour at EFRC but likes staying at the back of the cage on top of his shelter. He shows little interest in visitors.

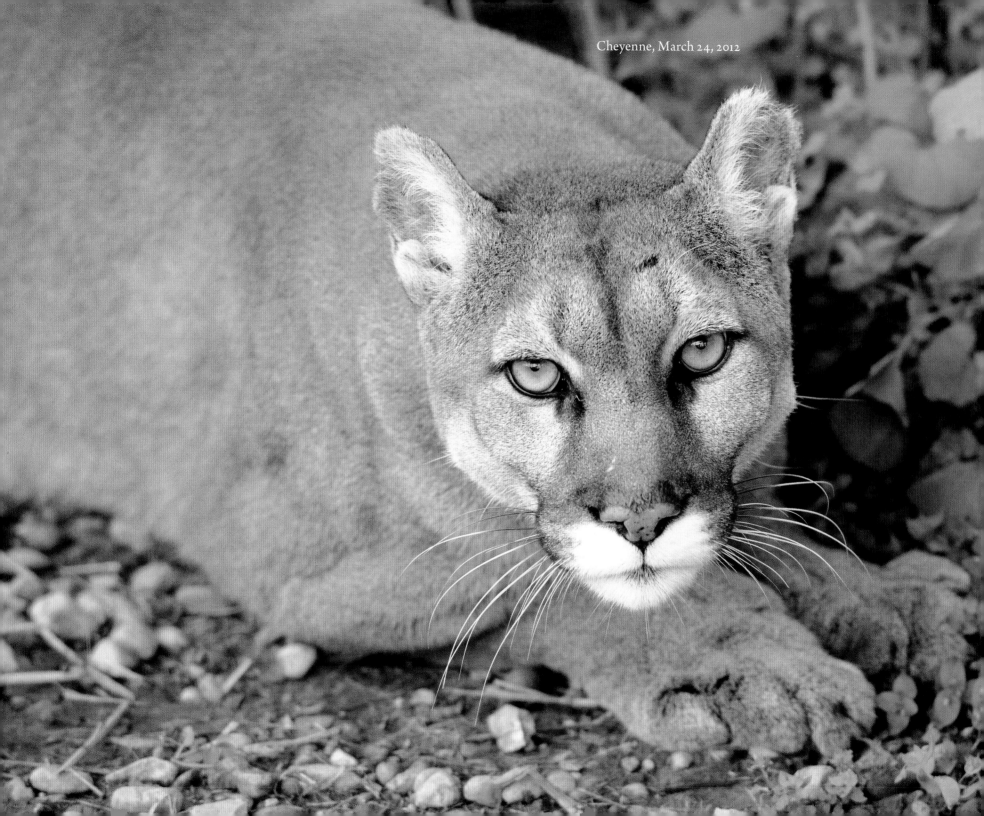

Cesar, July 17, 2014

Cheyenne, July 1, 2012

Three felids—Cesar, a male tiger; Cheyenne, a female puma; and Sasha, a female tiger—arrived at EFRC in November 2011 from Great Cats of Indiana, formerly known as Cougar Valley Farms, in Idaville. Great Cats had been under attack for years, accused of failing to provide "minimally adequate veterinary care to animals that were suffering." Great Cats eventually lost its license and was forced to close.

Stephen's Note: Cheyenne is a puma with an attitude. She specifically targets me and can pick me out of a large crowd. Felids can develop a bad attitude toward certain people for no apparent reason.

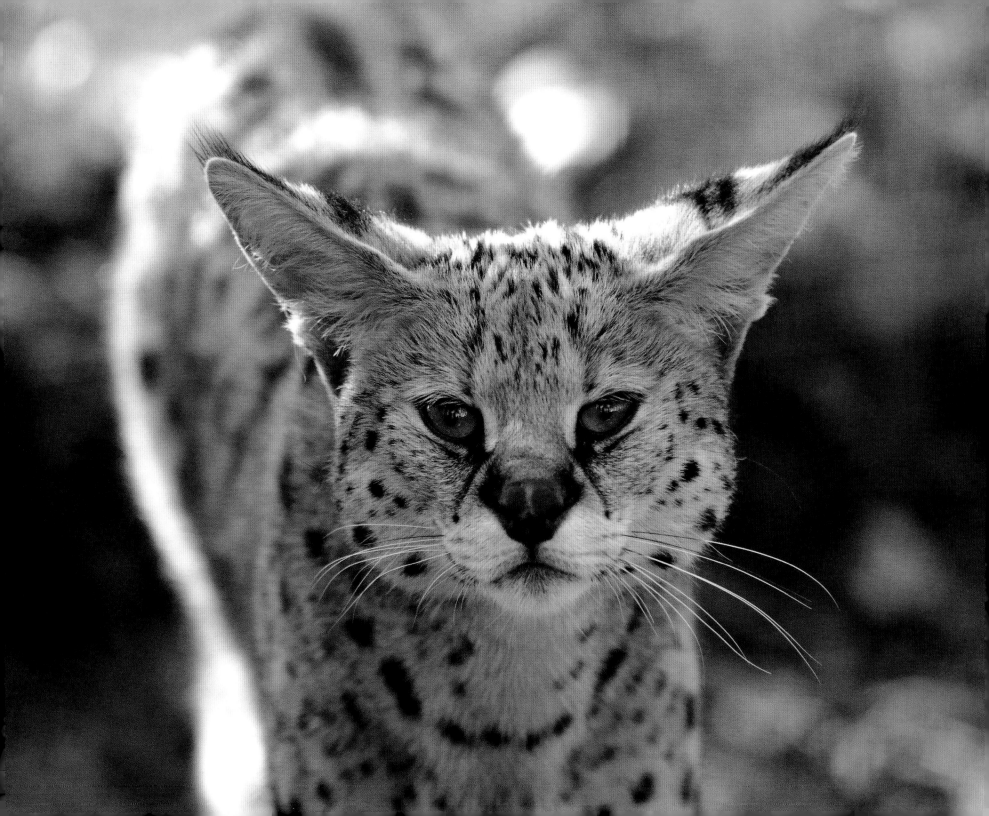

Cleo

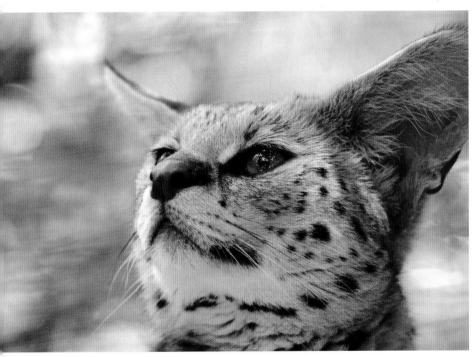

Cleo, July 17, 2011 *(above)* and February 16, 2012 *(right)*

Cleo, October 7, 2011 *(facing)*

Cleo, a female serval, has a rather common story. A recently divorced woman living near Cincinnati was having her house foreclosed and could no longer afford a serval as a pet. An EFRC employee transported Cleo from Cincinnati to EFRC.

Cleo lives with VinnieBob, a male bobcat. VinnieBob and Cleo were placed together because they had both lived with other cats and it was thought they might enjoy each other. Cleo seems to be the dominant felid in the enclosure. Like most servals, Cleo greets everyone with a snake hiss.

Dakota

Dakota, a female Canada lynx, was acquired from a private owner in Greenfield, Indiana. The owner's license for Dakota had expired and, due to Greenfield's expanding its city limits, he was being forced to make changes to Dakota's environment that he did not want to make. Dakota is on the EFRC standard tour and is very friendly.

Canada lynx are a member of the *Lynx* genus: Eurasian lynx, Canada lynx, Iberian lynx, and bobcat. They have large padded paws for walking on snow. Canada lynx range from Alaska to the northern United States. Blynx, a Canada lynx/bobcat hybrid, have been reported. The first instance of a Canada lynx/bobcat hybrid was reported in Minnesota. Blynx are a nonsterile hybrid.

Dakota, September 29, 2010

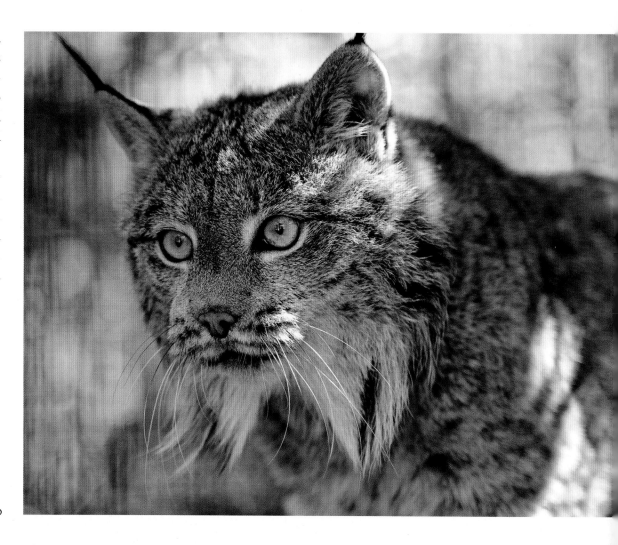

Dakota, June 24, 2013 (*facing*)

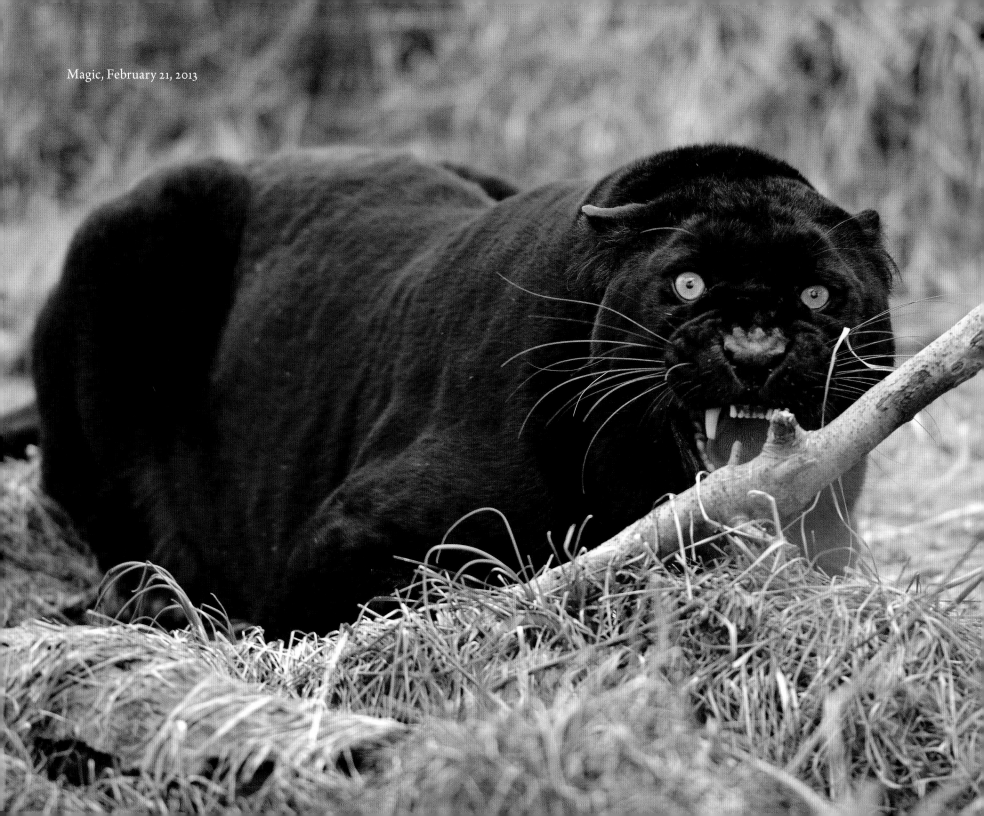

Magic, February 21, 2013

Dusty, Magic, and Mya

EFRC staff rescued one male tiger, Dusty, and two black leopards, a male named Magic and a female named Mya, from Fun Spot Amusement Park & Zoo in October 2011. This was EFRC's fourth and final trip to Fun Spot.

Fun Spot had housed eleven cats when the park closed nearly three years earlier. Although Fun Spot kept staff to care for the cats, the amusement park eventually had to relinquish all the animals. We agreed to take all eleven cats.

Three new habitats were built for the last of these cats and in early October, a full year after committing to take them, we were finally ready.

Magic is a very aggressive animal, and we knew both of the leopards we were rescuing would have to be immobilized. Dusty, however, was friendly and ready to come on his own. During the move he was examined by our veterinarian and blood tests showed he had low thyroid function. He was immediately started on medication and finally recovered.

Dusty is one of many animals that have had dental surgery at EFRC by the Peter Emily International Veterinary Dental Foundation (PEIVDF). PEIVDF provides life-improving advanced dental care and treatment to exotic animals located in captive animal facilities, which are underfunded and/or understaffed from a veterinary perspective.

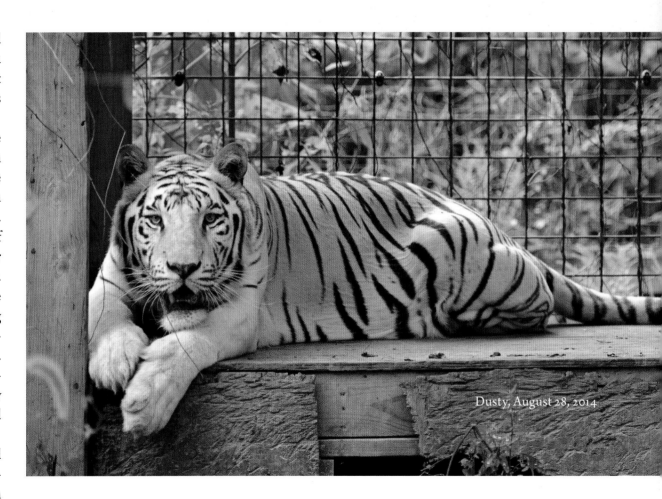

Dusty, August 28, 2014

Dusty is on the main tour at EFRC. He's extremely fond of his climbing tower. He and the female lion next door, Cera, seem to have something "going on"—they spend a lot of time at the fence visiting.

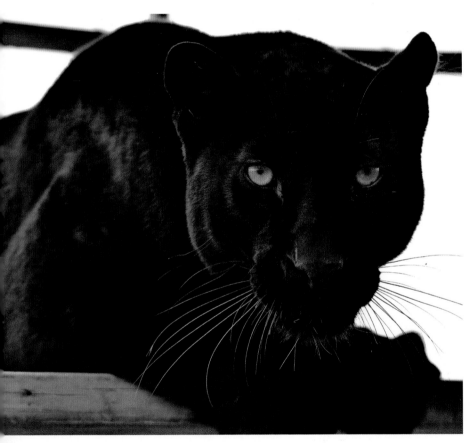

Mya, November 26, 2011

Dusty, August 28, 2014

Apollo, December 10, 2014

federal and state licenses, making it necessary to find new homes for its feline residents.

The New York rescue took four days. A team of five staff members left the Rescue Center on Monday, May 26 (Memorial Day), arriving in New York at 1:30 in the morning, and then attended a 6:00 AM briefing on Tuesday. The JNK facility was in shambles. The enclosures were pitifully small, covered in flies, smelling like rotten meat. By late Wednesday afternoon the tigers that would now call EFRC home were loaded and ready for transport. After another long drive, the EFRC team arrived in Center Point at 1:30 AM on Thursday with the new residents (they sure do like those early morning arrivals).

The Rescue Center took six tigers during the rescue. Four of the tigers appeared underweight, two had cataracts, and several had dental problems. While all of the tigers successfully arrived at EFRC, a small male died the morning after the return. The animal was necropsied to determine the exact cause of death; he had a heart condition and had died of cardiac arrhythmia.

In late May 2014, EFRC was one of several organizations that participated in a seizure of more than twenty exotic animals from a facility called JNK's Call of the Wild Sanctuary in New York. One of the two owners had passed away several months before and the sanctuary lost its

Three of the tigers—males Sebastian and Apollo, and a female, Shantel—live together in a new enclosure that includes a climbing tower and a large water tank. The other two, Magic (male) and Mystic (female), live together in an extensively renovated older tiger enclosure in a wooded area. Visitors might be able to catch a glimpse of them from Max and Kisa's area.

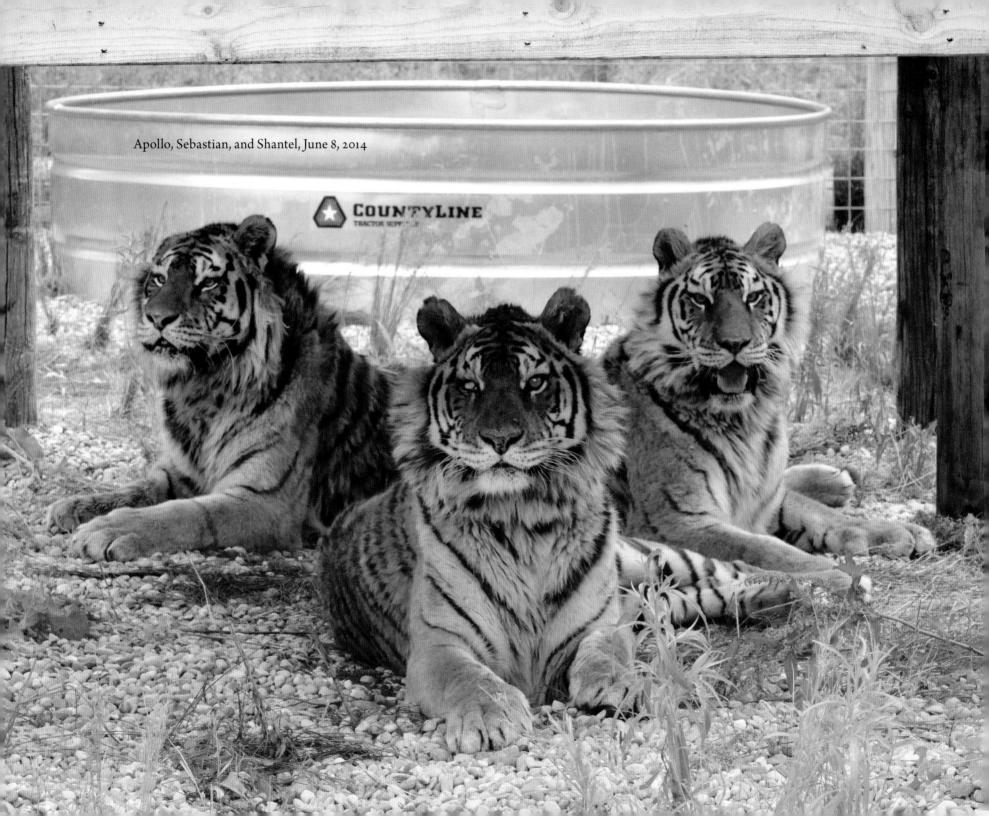

Apollo, Sebastian, and Shantel, June 8, 2014

Magic, December 20, 2014

Shantel, November 6, 2014

Shantel, December 10, 2014

Kali, Kya, Pearl, and Storm

In 2010 four tigers—two females, Kali and Kya, and two white males, Pearl and Storm—were seized from Roy "Boy" Cooper's tattoo parlor in the Glen Park section of Gary, Indiana. A USDA spokesman described the tigers as underweight and lacking proper veterinary care. The tigers appeared to be suffering, the spokesman said, meeting the legal threshold for the USDA to confiscate them. The tigers were tranquilized and loaded for transport to EFRC.

At the direction of federal agents, Cooper waited inside his office. Cooper claimed the USDA had made constant demands that were impossible for him to keep up with. He said it seemed like they were trying to make an example of him.

The oldest of the tigers appeared to be Pearl, possibly acquired by Cooper in the 1980s. Pearl was missing his tail, which was reported to have been bitten off by the tiger Storm when Pearl's tail strayed into Storm's cage.

Cooper claimed to have acquired Storm from Mike Tyson. According to one of Cooper's former mothers-in-law, this was not true, "just a lie to try to impress people." Mike Tyson did have a white tiger named Storm but that tiger was a female. Kya was probably purchased for $300 by Cooper from a small "zoo" in Iowa in 2007 when she was about three months old.

After their arrival at EFRC, the four tigers gained weight and their coats improved. The tigers were not the worst that EFRC had ever seen, but they are better off than they were at the tattoo parlor.

Cooper died at the age of sixty-four, not long after giving up the tigers.

Two state troopers and the USDA provided security for this rescue. Friends of the tattoo parlor were angry about the removal of the tigers.

Storm, November 6, 2011

Stephen's Note: Kya is one of the felids at EFRC that likes me. She can pick me out of a crowd and follow me around, all the time chuffing or rubbing up against the fence. She is difficult to photograph.

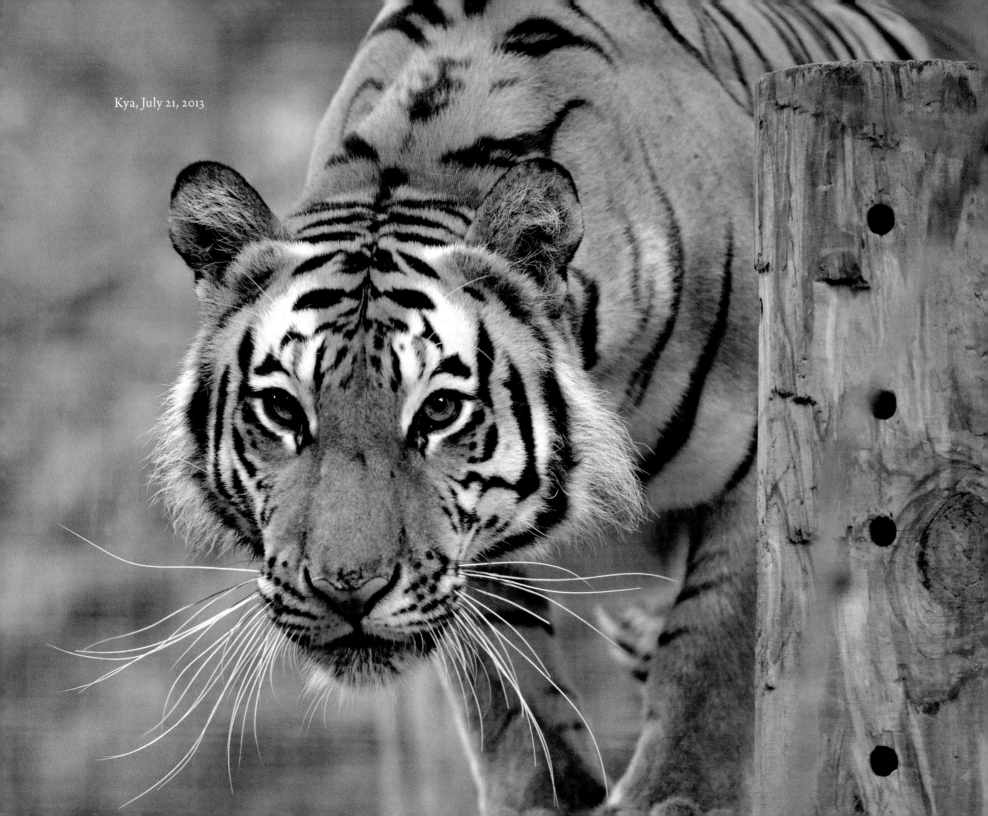

Kya, July 21, 2013

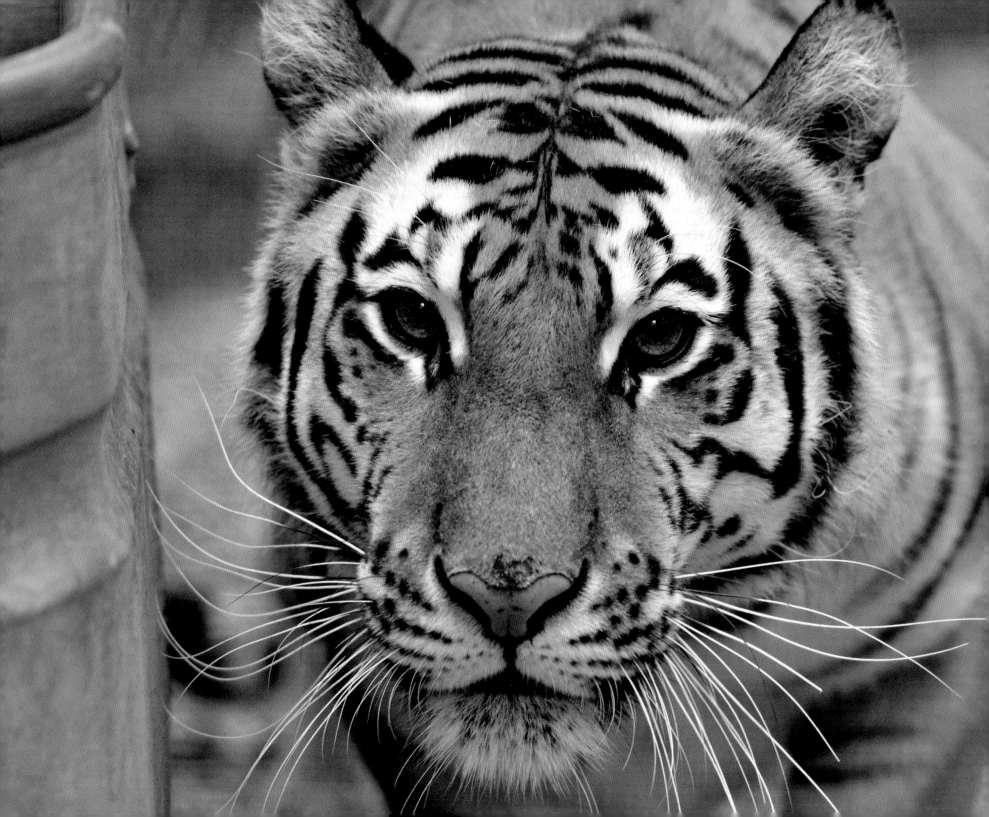

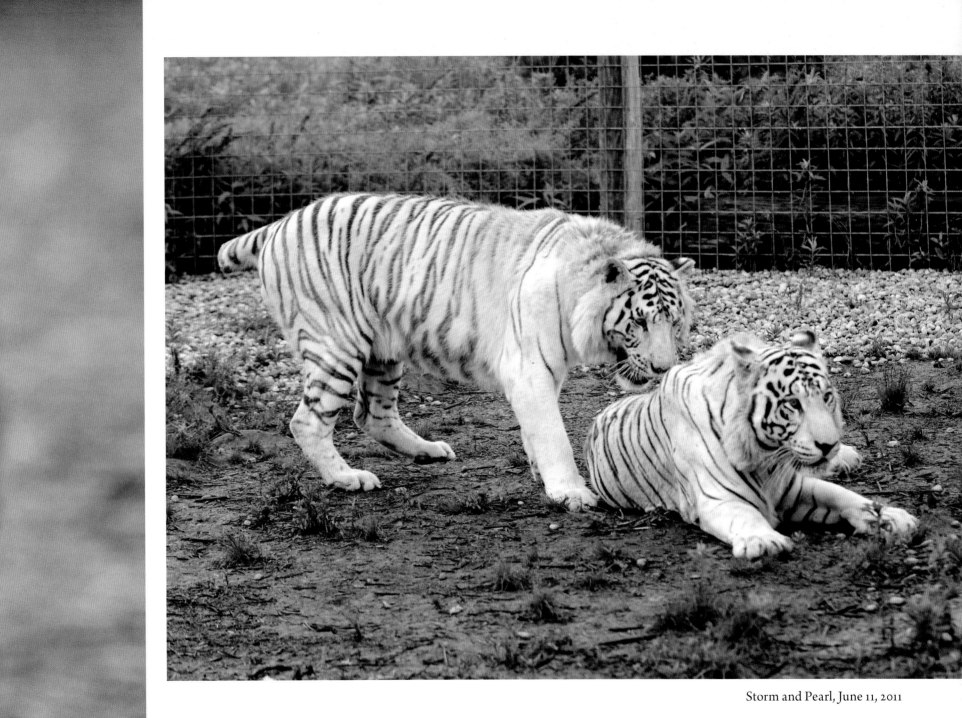

Storm and Pearl, June 11, 2011

Kya, August 2, 2013

Desi, Luci, and Tawny

Desi, September 29, 2010

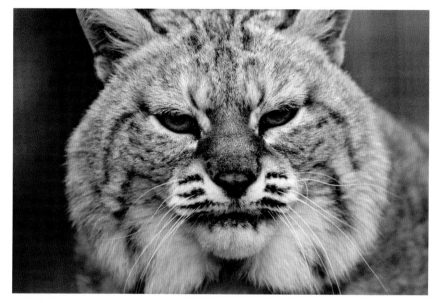

Luci, March 21, 2010

In 2008, authorities in Idaho came to an agreement with Sandy Knox, a woman in her mid-seventies, to relinquish several wolves, five bobcats, and cats and dogs too numerous to count. She had been accused of keeping them in deplorable living conditions, and the deal allowed her to avoid criminal charges of animal cruelty.

"I love wild animals because they aren't mean or ornery like people. They just love you," Knox said. She was allowed to keep two bobcats and two wolves.

After months of negotiations, authorities from the county, the Idaho Humane Society, Idaho Fish and Game, and the USDA arrived at her house and transported the animals to a garage where they were examined by veterinarians. The animals were reported to be in good health.

Five wolves were sent to the Wolf Education & Research Center in Winchester, Idaho. Twelve wolves went to the Big Oak Wolf Sanctuary in Green Cove Springs, Florida. Cats and dogs went to the Humane Society in Boise. Three of the bobcats—one male, Desi, and two females, Luci and Tawny—were transferred to EFRC from the Idaho Humane Society.

Desi, December 26, 2009

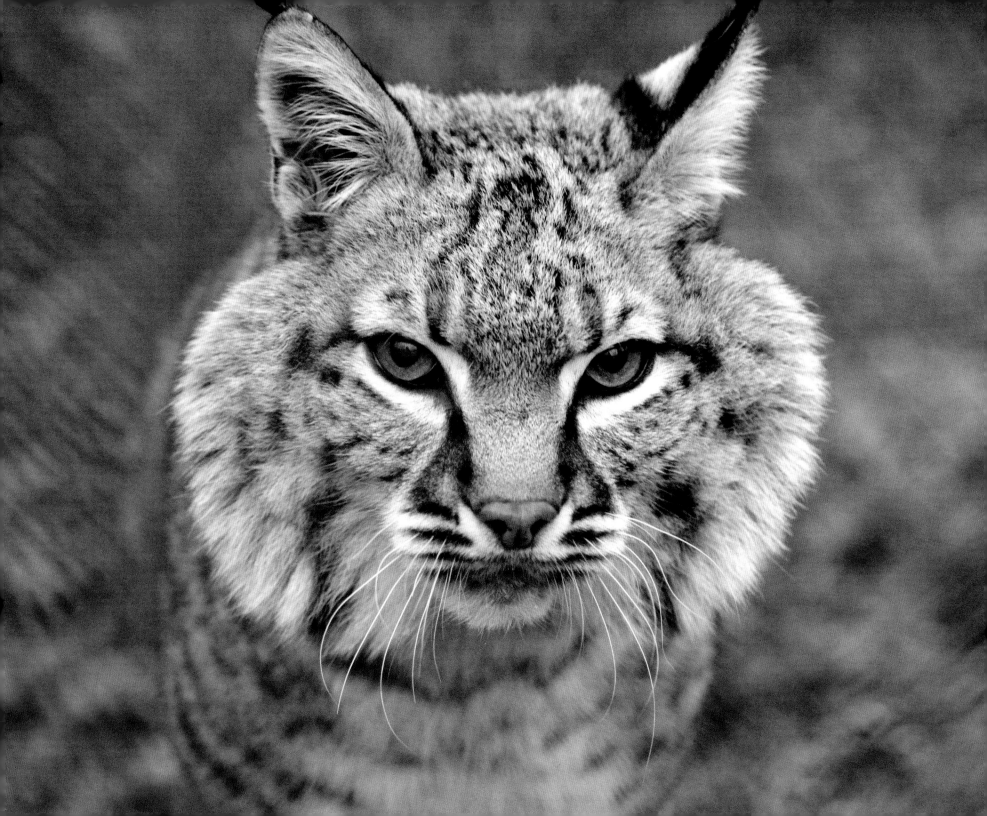

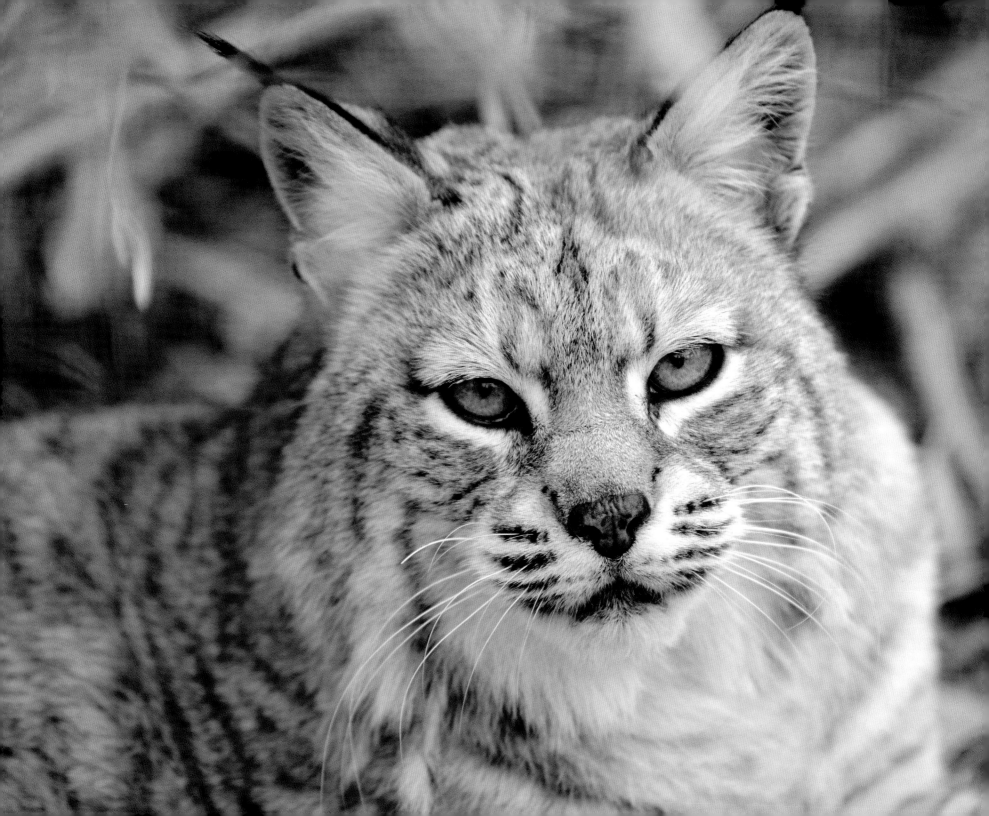

Tawny, December 20, 2009

Tawny, February 27, 2011

Christopher, Mariah, and Savannah

In the winter of 2010, EFRC staff rescued three tigers—Christopher, a male; Mariah, a white female; and Savannah, a female—from the Fun Spot Amusement Park & Zoo in Angola, Indiana. Unfortunately this would not be EFRC's last rescue at Fun Spot.

Mariah, April 20, 2012

Princess II, RA, Samo, Tony IV, Zoe, Simba, Thor, and Zeus

On a snowy morning in February 2010, a call came in from the USDA, asking us to take five tigers (females Princess II and Zoe and males RA, Samo, and Tony IV) and three lions (Simba, Thor, and Zeus, all males) and assist in the removal of two more exotic felines. They added, "Can you do that today?" Ten big cats in dirty, rusted old circus carts locked in a barn in northern Indiana were to be confiscated. They had been owned by a seventy-two-year-old retired Miami circus performer, and the USDA had decided to remove the animals, citing "insufficient space." Being one of the only organizations in the country capable of taking ten large predators with no advance notice, we headed north, crawling through a blinding snowstorm at fifteen miles per hour and arriving at the rendez-vous point late. There we were met by a large turnout of federal and state officials and were promptly escorted to the site.

Federal and state agents kept the owner at a distance as we surveyed the situation with USDA officials and our staff began unloading three truckloads of equipment. Some of the animals loaded readily. One lion required immobilization and another had to be taken in her cage, afraid of leaving the tightly confined space (about seven square feet) where she had always been kept.

By dark, all of the cats were loaded and on their way to a new and better life. The day after their arrival all of the animals were examined by Fred Froderman, our veterinarian. We then scheduled a procedure for the following morning for Princess, who had two claws ingrown into her pad, which caused difficulty walking.

Samo, one of the male tigers, was missing large portions of his coat and had sores and lacerations on two of his legs and his tail. Sanitation, antibiotics, a proper diet, and a large enclosure provided Samo with a chance to recover.

Simba, March 4, 2012

The first two cats to be put in permanent enclosures were Thor and Zeus, two male lions who were barely able to walk. After being in their enclosure for a month they ran for the first time, although not very well. All of the animals were soon placed in large permanent enclosures.

All of the animals had an amazing transformation and did well. We are often highly critical of the USDA Animal and Plant Health Inspection

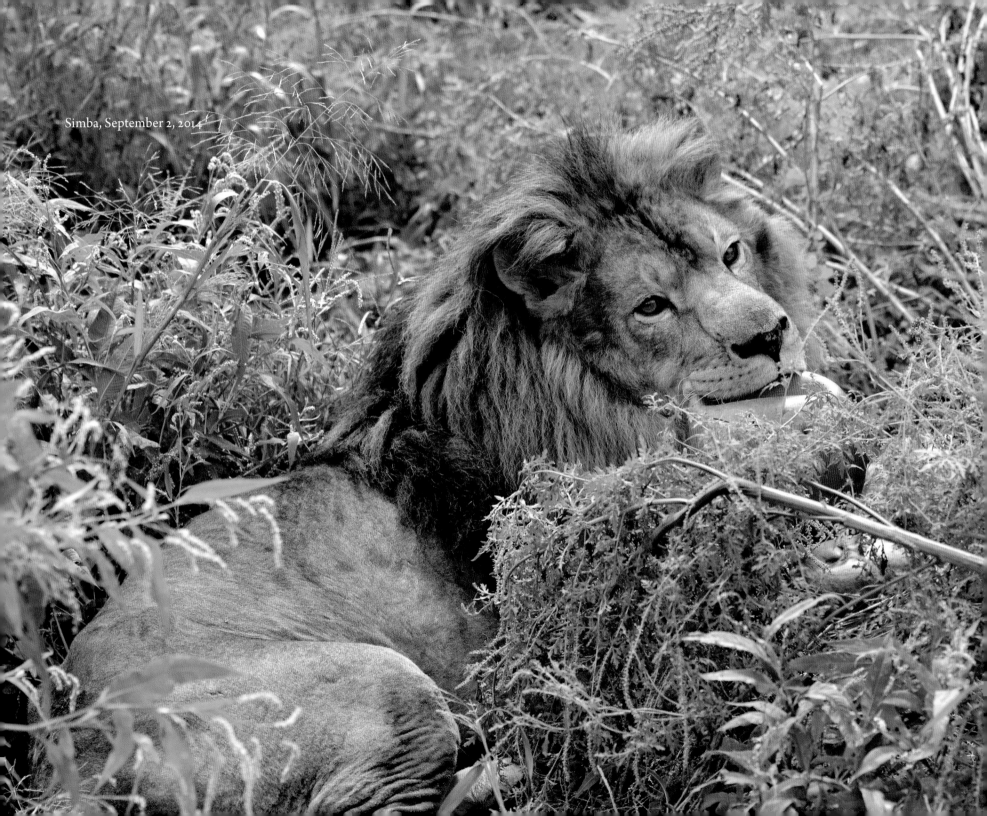

Simba, September 2, 2014

Service's policies and actions concerning the welfare of big cats. This time, however, we were gratified by a large and determined APHIS presence.

Stephen's Note: Since Thor and Zeus have learned to walk and run they have learned to pose for photography. Along with Max and Kisa, Thor and Zeus are high on the list of animals to check for photos during each of my visits to EFRC.

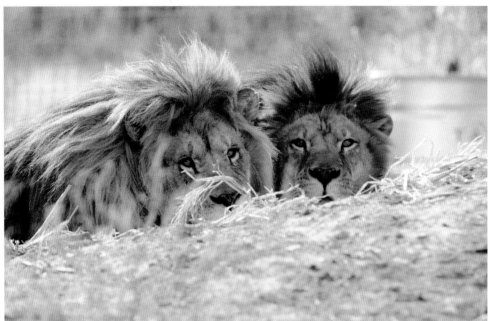

Thor and Zeus, November 4, 2010

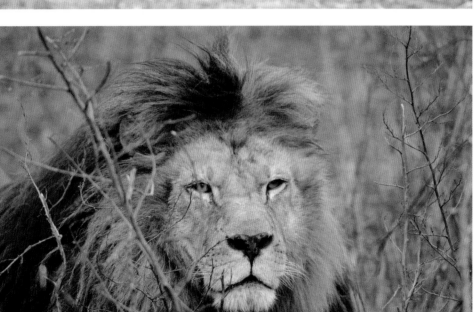

Zeus, November 5, 2014

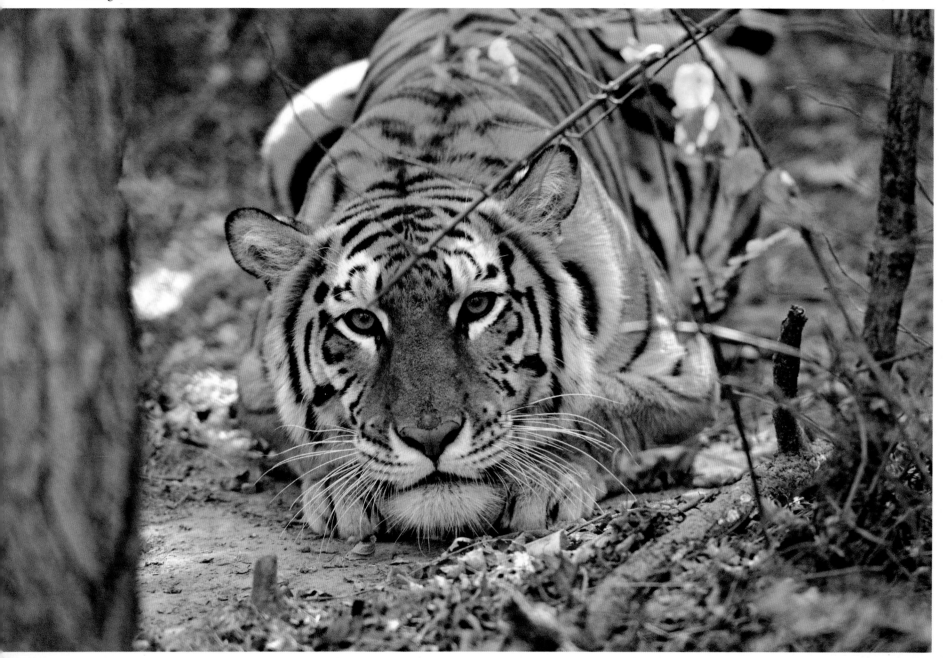

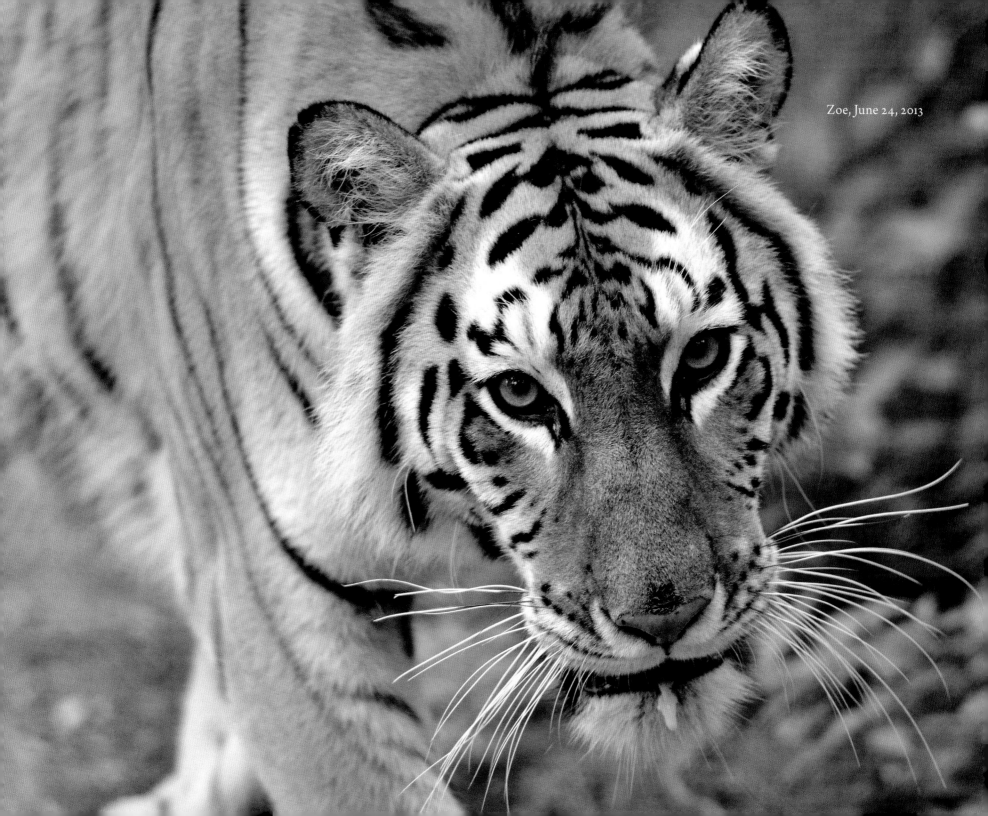
Zoe, June 24, 2013

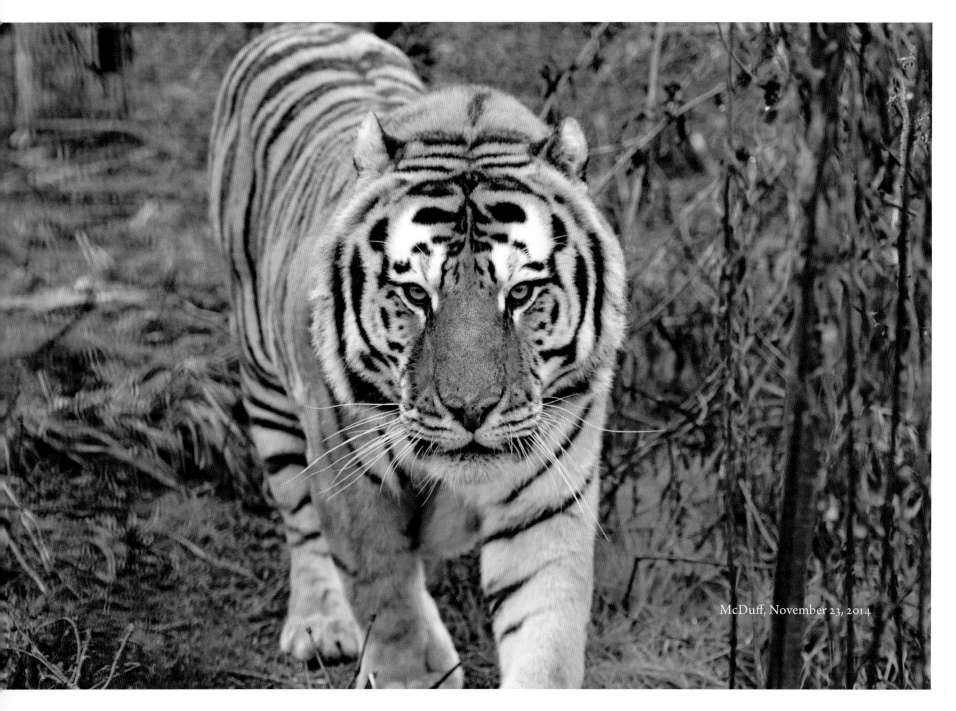

McDuff, November 23, 2014

Elizabeth and McDuff

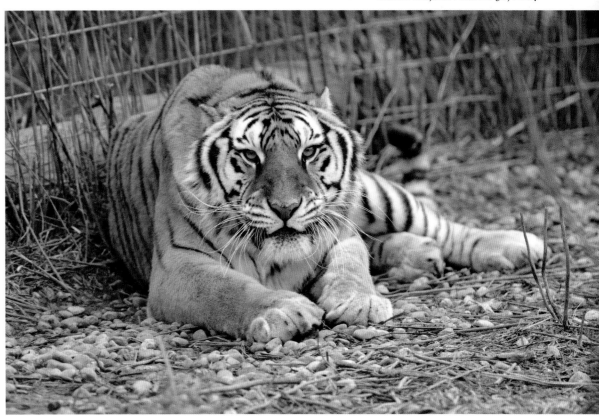

Elizabeth, November 30, 2014

In the fall of 2014, two tigers were rescued from North Carolina. The tigers were taken in at a young age by a couple not willing to see them euthanized because of broken legs. After providing them with veterinary care and nursing them back to health, the couple built one of the most beautiful tiger cages we had ever seen on a rescue. Located on the edge of a rock quarry, this large enclosure was filled with trees, large boulders, natural caves, and water pools.

Unfortunately, a little over a year before the rescue the wife died, the husband was confined to a wheelchair, and the care of the tigers fell to their daughter, who provided necessary care while looking for a home. In early October 2014, a group of staff and volunteers from the Rescue Center made the long trip to North Carolina, where the tigers were successfully captured, crated, and brought back to Indiana. Upon arrival they were given a complete physical exam.

The male, McDuff, had a severely swollen front paw and could barely walk. During his exam he was found to have several ingrown claws, a condition not uncommon in older animals. Once his claws were trimmed the male began to adjust quickly. The female, Elizabeth, began to come around and trust her new keepers while enjoying life in a big, beautiful enclosure with a climbing tower and cement pond. Their enclosure is located on the periphery of the property where their contact with strangers is limited.

Overnight visitors who get to see all of EFRC might be surprised to find that McDuff's enclosure sign reads "Fluff McDuff." When McDuff arrived he had two different names, and after some indecision about what to call him, they were combined.

Transportation for this rescue was funded by a grant from Tigers in America.

Annie, Brooke, Cera, Ezmeralda, Mr. Bigglesworth, Scooby, Shasta, and Tasha

Like Blackie, Munchie, and Rajah, these eight animals—female lions Annie, Brooke, Cera, and Scooby; female tigers Ezmeralda and Shasta; male serval Mr. Bigglesworth; and female bobcat Tasha—were sent to EFRC from the William Sheperd Wild Animal Orphanage in Uniontown, Pennsylvania.

Annie, December 10, 2014

Brooke and Annie, September 20, 2013 (*facing*)

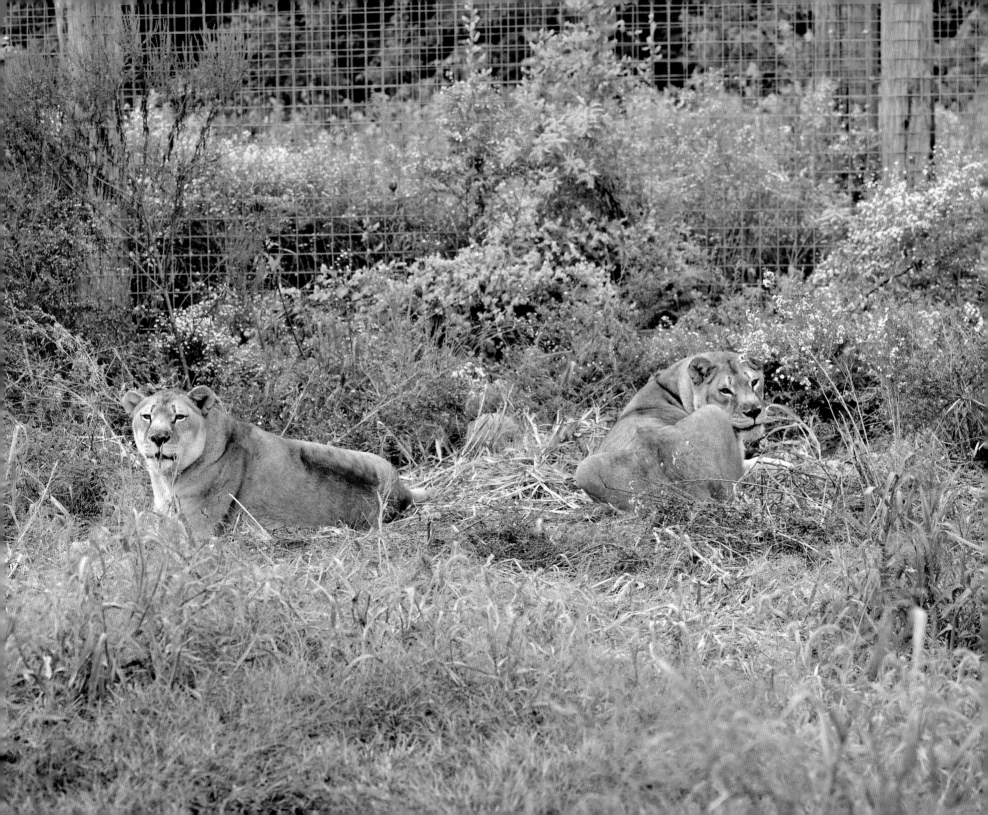

Cera, December 9, 2014

Cera, December 3, 2014

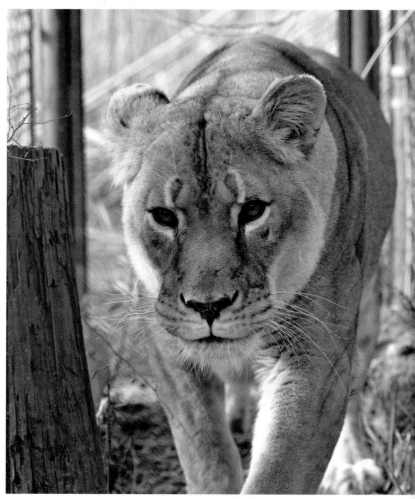

Mr. Bigglesworth, December 14, 2012

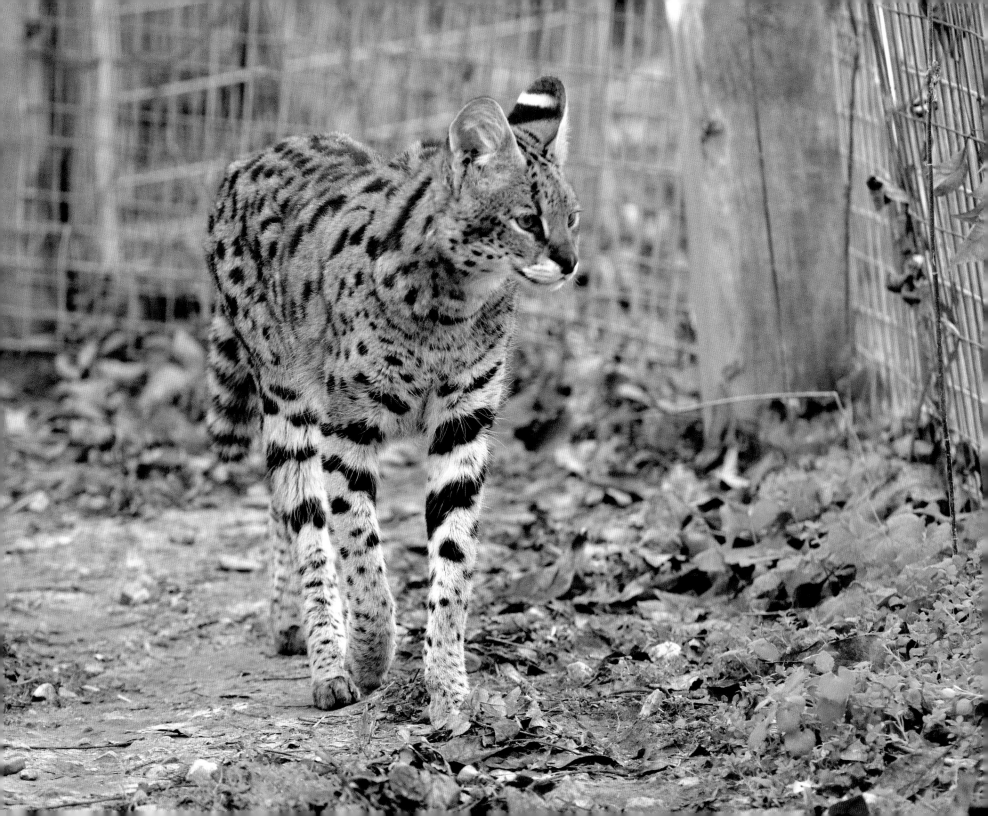

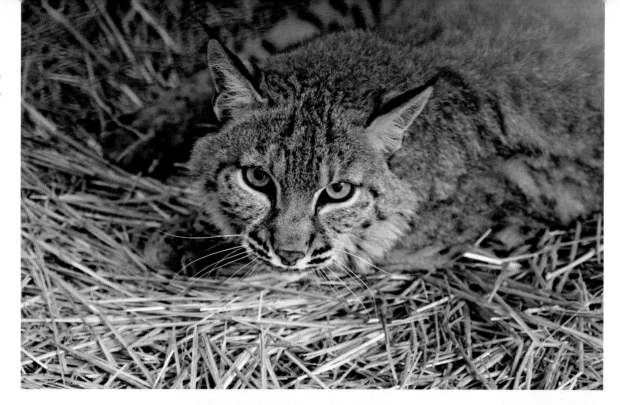

Tasha,
June 7, 2013

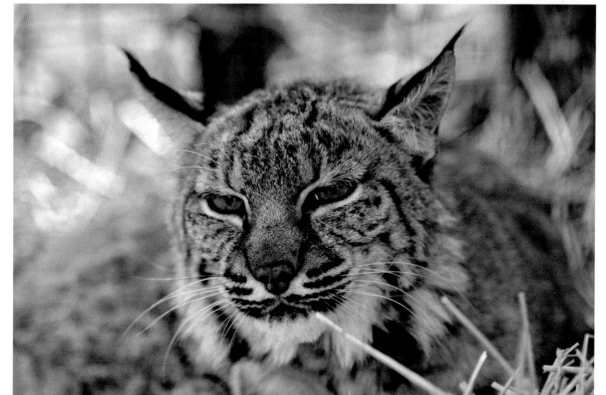

Tasha,
November 5,
2014

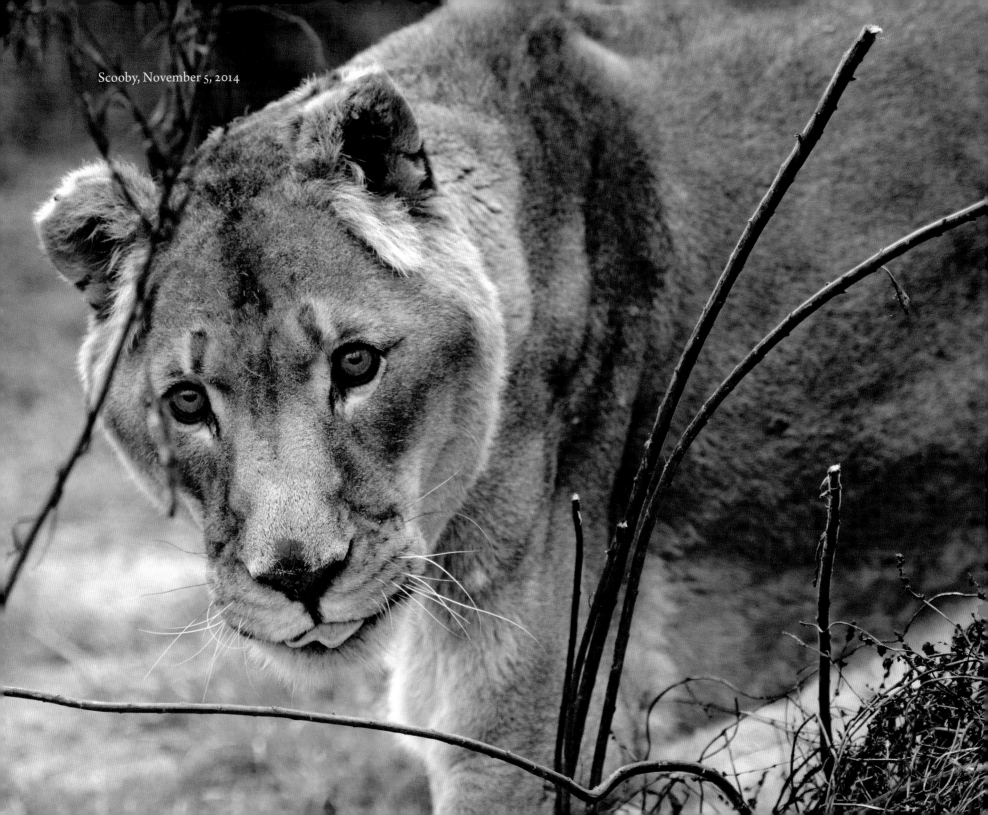

Scooby, November 5, 2014

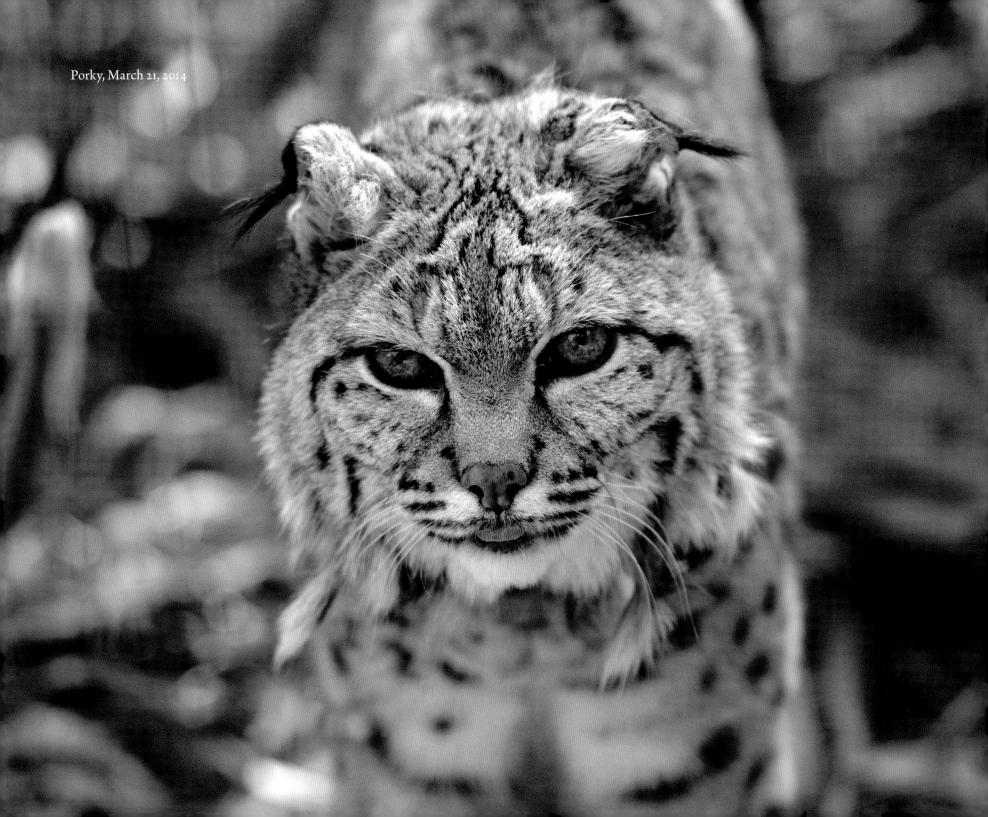

Porky, March 21, 2014

Kendra, Kiera, Missy, Porky, Raja Boy, Tigger, and Vaughn

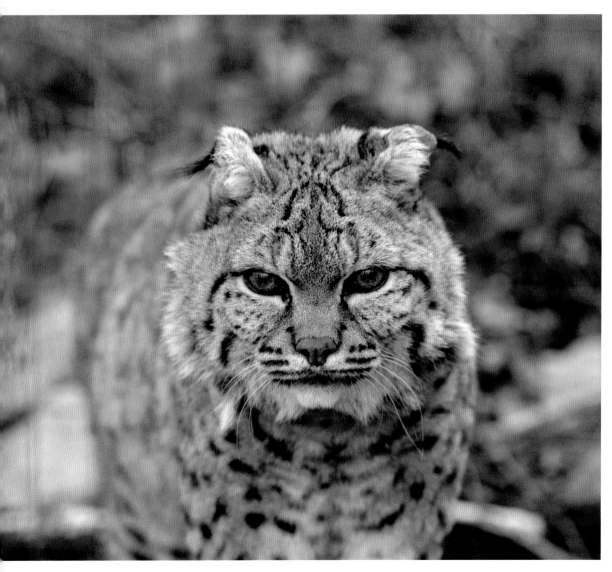

Porky, December 21, 2014

In May 2012, the state of Indiana received reports of malnourished animals and inadequate cages at Great Cats of Indiana, in Idaville. When officers arrived they found animals in horrible conditions. All of the animals were seized. The USDA and the state of Indiana had had complaints about the facility for years.

Three of the tigers were grouped together and entered their transport cages without pause, apparently eager to head south. Assisting on this complex rescue were EFRC staff and several volunteers, all supervised by Indiana Department of Natural Resources law enforcement due to the circumstances surrounding the rescue.

On May 29, 2012, EFRC took in nine new residents: female tigers Kendra and Kiera, male tigers Tigger and Vaughn, female lion Missy, male puma Raja Boy, female bobcat Porky, and two hybrid wolf dogs, Nanook and Six. The two wolf dogs were a surprise. Transport cages were purchased at a local farm store and the dogs were brought to the center for temporary care to avoid the possibility of euthanasia. The wolf dogs were relocated to Black Pine Animal Sanctuary in Albion, Indiana. Black Pine had taken in the rest of their pack at an earlier date, and although EFRC staff and volunteers had already fallen in love with Nanook and Six, it was wonderful to see them reunited with their pack.

Jasmine, Lindsey, Romulus, Shahzara,
Sheikhan, and Tecumseh

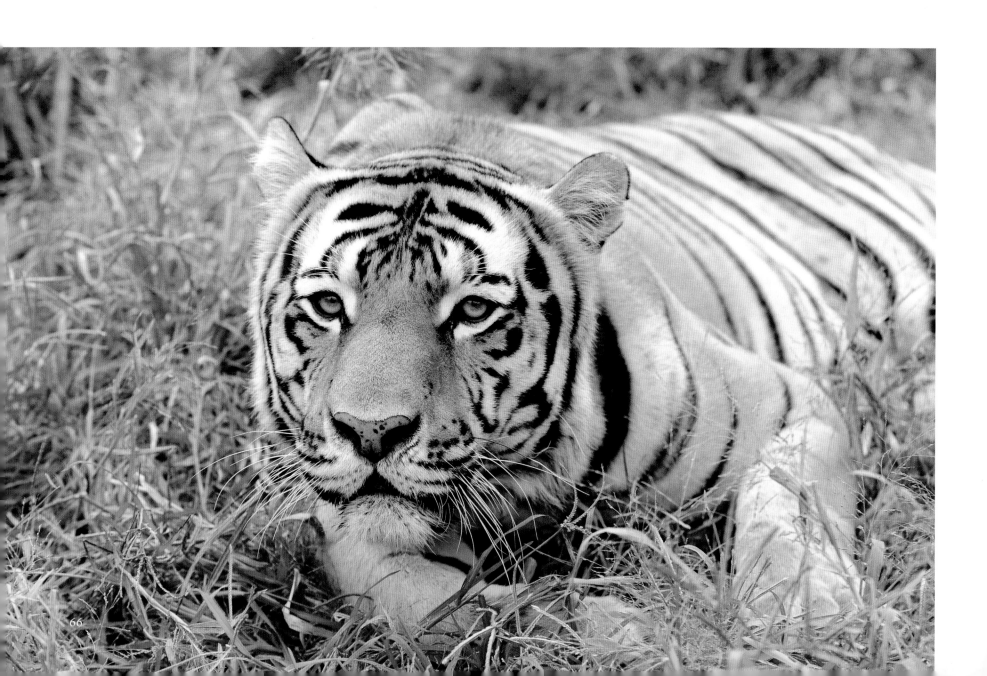

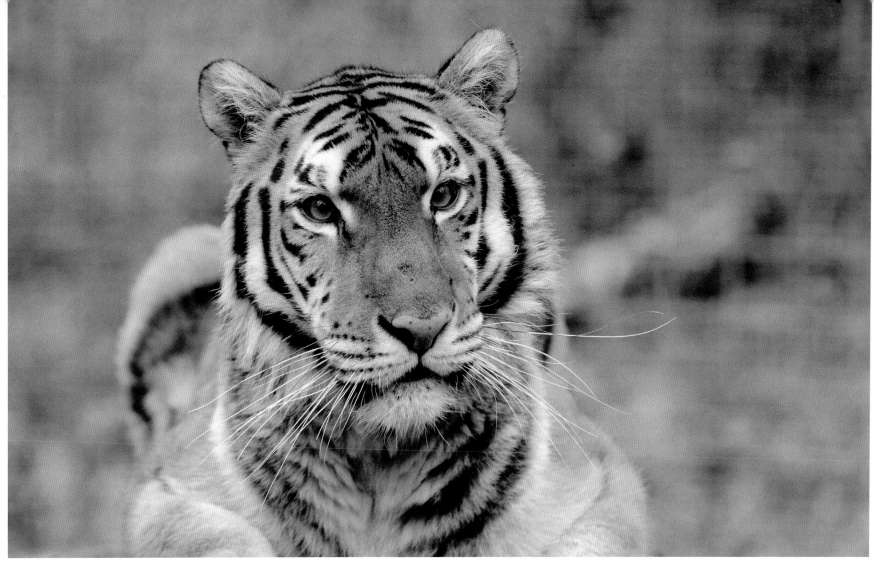

Romulus, October 3, 2010 (*facing*)

Jasmine, February 27, 2011

In the fall of 2009, EFRC took control of several felids from Anna Horton's Enchanted Gardens Sanctuary in Tell City, Indiana: three male tigers, Romulus, Sheikhan, and Tecumseh; a female tiger, Shahzara; a female puma, Lindsey; and a female tigon, Jasmine.

A tigon is a hybrid cross between a male tiger and a female lion; the parents are of the same genus (*Panthera*) but different species (*tigris* and *leo*). Tigons can have characteristics of both parents, including spots from the mother (lions carry genes for spots; lion cubs are spotted and some adults have faint markings) and stripes from the father. The manes of male tigons are shorter and less noticeable than those of lions, and may be closer to the ruff of a male tiger. Tigons are smaller than tigers because they carry the growth-inhibiting genes of lions, but they may weigh up to four hundred pounds. Tigons are often thought to be sterile, but they have been known to conceive and bear offspring.

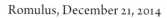
Romulus, December 21, 2014

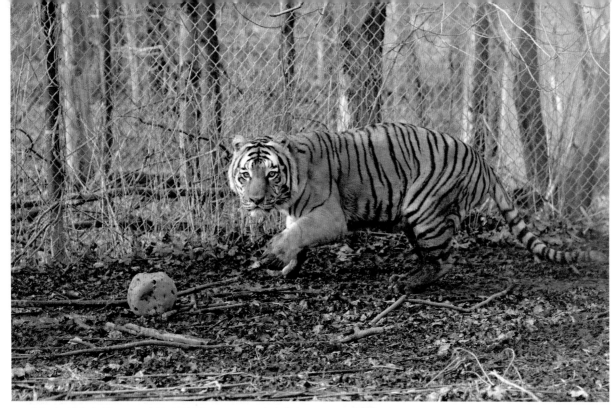

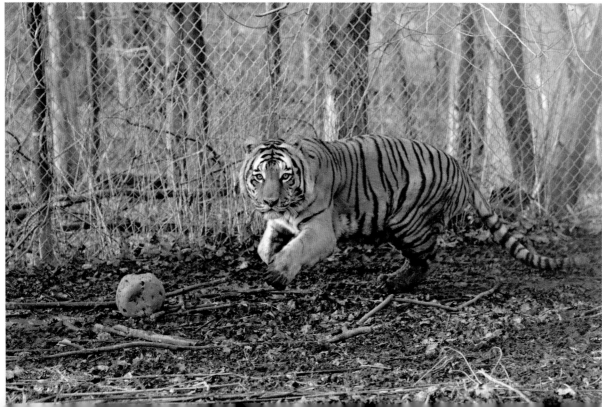

68

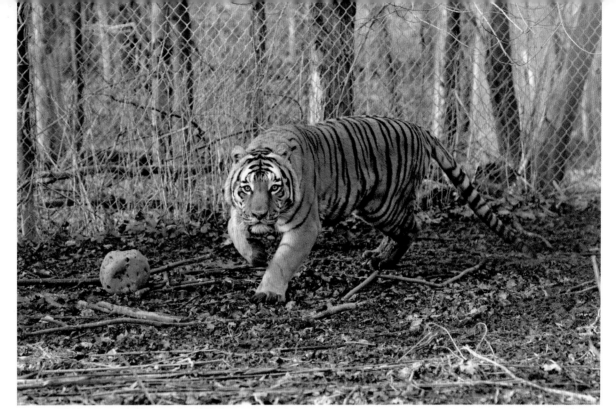

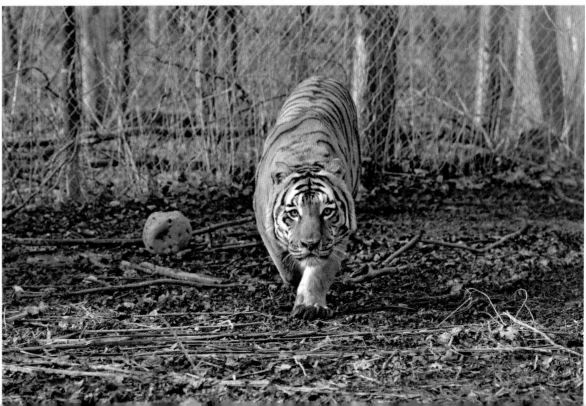

Blaze, Callisto, Gabriel, Ozzy, Raj, Rogue, Sahib, Sampson II, Scarlett, Star, Storm II, Sultan, and Tajie

The sanctuary business is a tough business. It is full of people with good intentions and no experience, scammers, and frauds, as well as hard-working people who tirelessly strive to provide quality care for their animals, often in very adverse conditions. The failure of a large sanctuary, whether legitimate or fraudulent, carries a greater impact than the closure of an animal show, illegal pet owner, or any other animal venue.

For a while there had been rumors of the pending closure of the Wildlife Animal Orphanage (WAO), but the call to come take cats was bad news. Of the seventy-plus cats needing relocation, we were pressed to take thirteen—seven males and six females—which would bring our total to thirty-nine new cats in 2010 and increase an already lengthy waiting list.

A 2,500-mile trip for thirteen tigers, and with little help on the ground in Texas, meant taking a large crew and a lot of equipment. A semi truck with two drivers was loaded with thirteen transport cages, plywood, game fencing, a generator, extension cords, fans, and around 1,500 pounds of meat for the cats that still remained at WAO. In addition, two drivers and a pickup truck loaded with tools, caging materials, chains, and locks, and a driver in a van loaded with veterinary supplies including fluids, IV sets, vaccines, immobilization drugs, a pole syringe, and darts, left Indiana. Along the way, we were met by

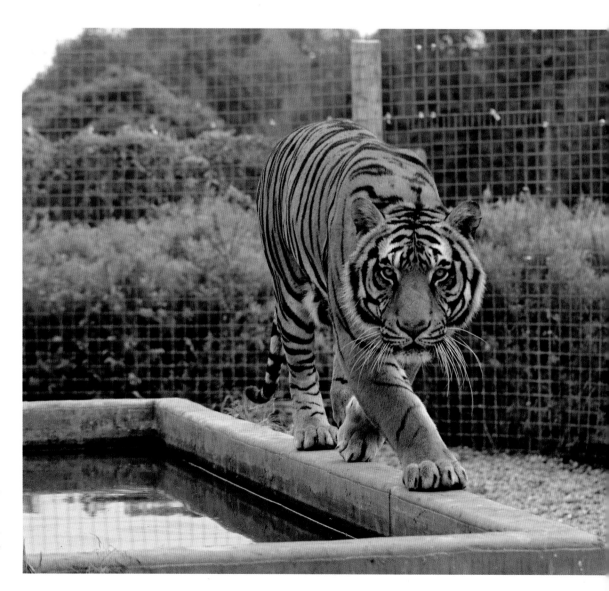

Blaze, September 18, 2011 *(facing)*

Rogue, September 10, 2011

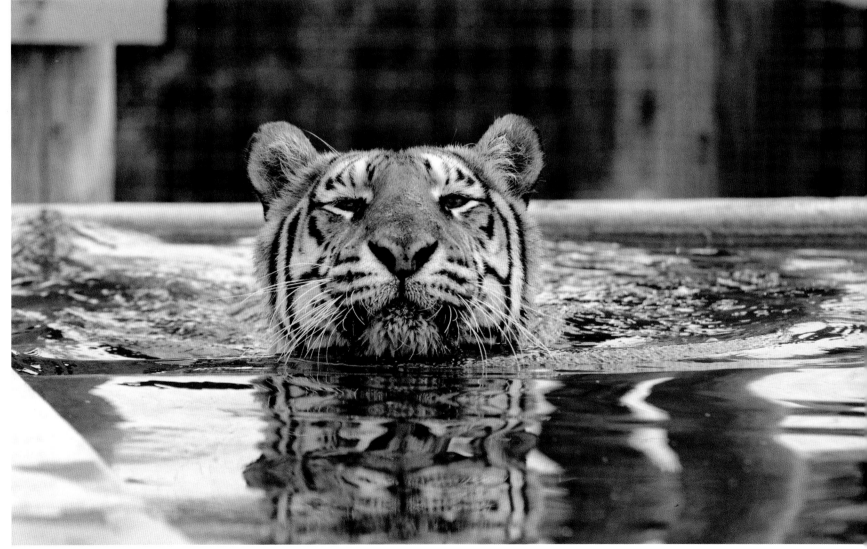

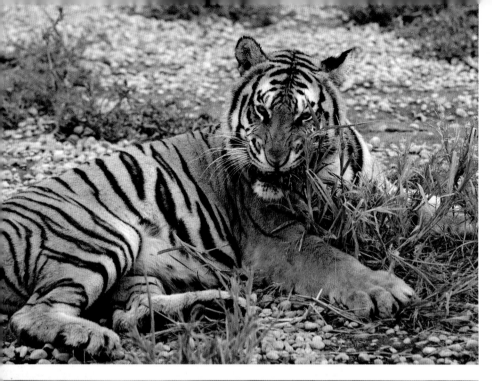

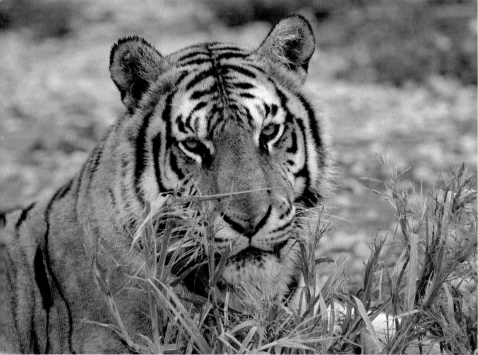

another car with keepers from the Louisville Zoo and they had brought their dart gun.

We arrived in Texas with a total staff of nine people and met up with USDA personnel, and together we made a site visit and prepared a plan for the next day. It took all morning and afternoon to load the first six tigers. By late in the afternoon we resorted to tranquilizing drugs. Seven tigers were immobilized quickly and without incident. Once immobilized, they were examined, blood was drawn, and each cat was given three liters of fluid. In a state of exhaustion, we stopped for the night, not yet in Dallas. After a brief sleep we drove nonstop for home.

We returned to EFRC late Thursday evening and by noon on Friday, six of the tigers were safely released into their newly built enclosure. The enclosure includes a fifteen-by-fifteen-foot in-ground cement pool. Several of our tiger compounds have these pools. Another feature in our habitat is a four-deck climbing tower. There are two large, covered shift cages with multiple den boxes and loafing platforms built inside this habitat as well. The rest of the tigers were moved into temporary holding cages inside the meat processing building, where they stayed until their new enclosures were completed.

The moving of a large group of tigers is a complex and costly endeavor. It took nine people and four days and cost over $6,000 to move these cats. Keeping the cost to a minimum was only possible because of people volunteering their time, and because Kenworth of Indianapolis donated the truck for the trip. A $1,000 transportation grant from the FCF Wildcat Safety Net Fund also helped make this rescue possible.

Stephen's Note: This group includes Sahib, a male golden tabby tiger. A tabby tiger is a tiger with a color variation caused by a recessive gene. This makes for some beautiful images. Sahib lives across from Max and Kisa, and Sahib seems to enjoy entertaining Max.

Rogue, September 18, 2011 (*both photos*)

Sahib, November 26, 2011 (*facing*)

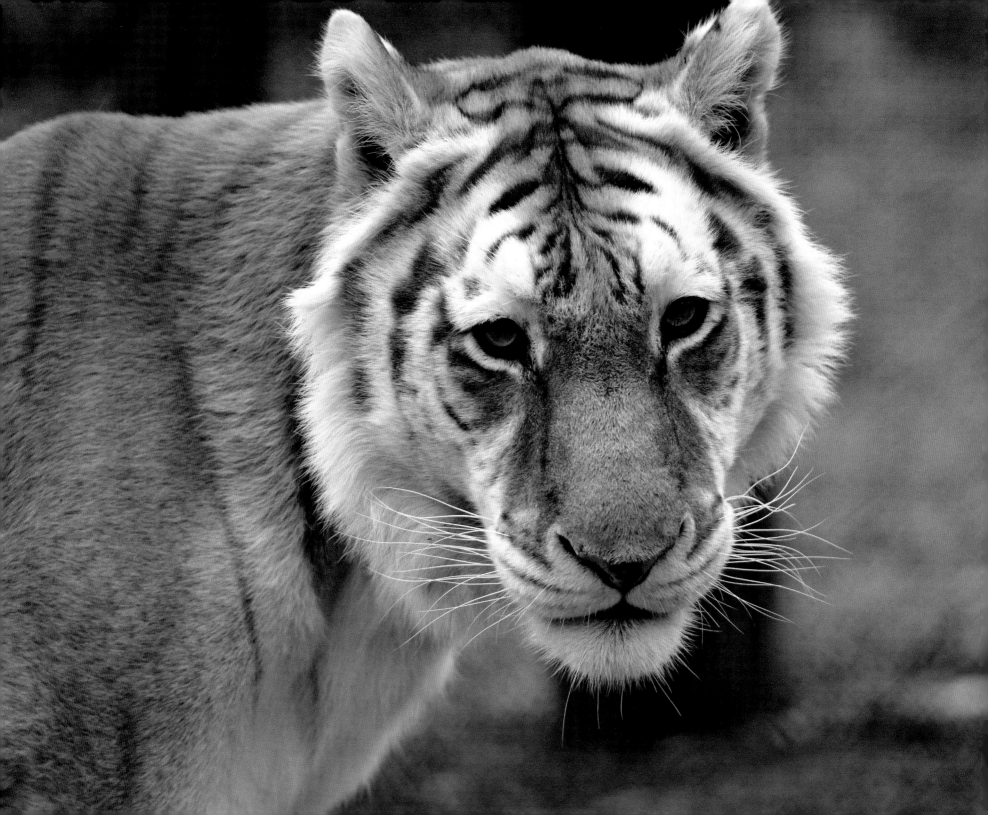

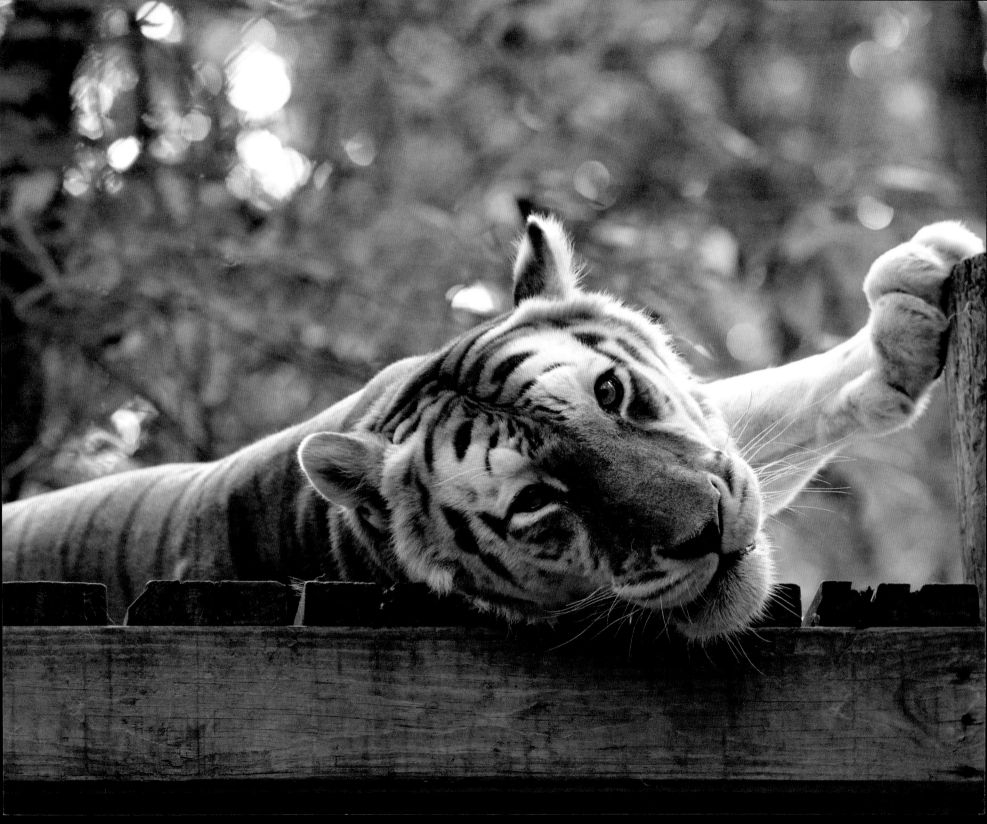

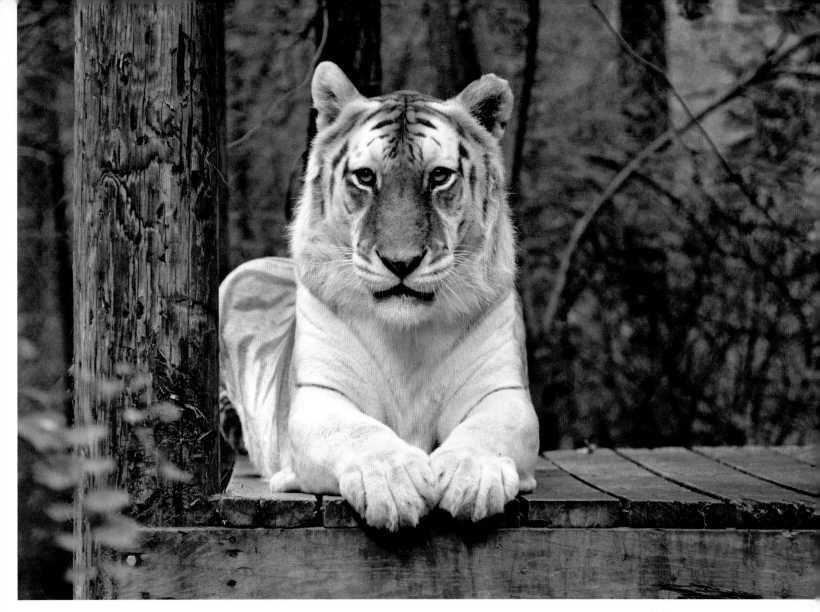

Sahib, August 10, 2013

Sahib, September 13, 2013

Sampson

Sampson is an F1 Savannah cat who was seized by the US Fish and Wildlife Service in New Hampshire. He arrived at EFRC on December 27, 2012. A Savannah cat is a hybrid cat that is the offspring of an African serval and a domestic cat. Hybrid crosses are classified by filial generations; F1 is the first generation (the children). Cross an F1 with another domestic cat to get an F2 (the grandchildren). Cross an F2 with another domestic cat to get an F3 (the great-grandchildren of the serval).

Many, but not all, jurisdictions limit private ownership to F3 hybrids. Savannah cats are banned as exotic animals in some parts of the United States. They are known for their tail, slender bodies, big ears, and exotic-looking patterns retained from their serval heritage. They also retain another common serval trait—they can be unfriendly cats!

Servals tend to pair-bond with the first human they meet. Savannah cats can cost $3,000 or significantly more.

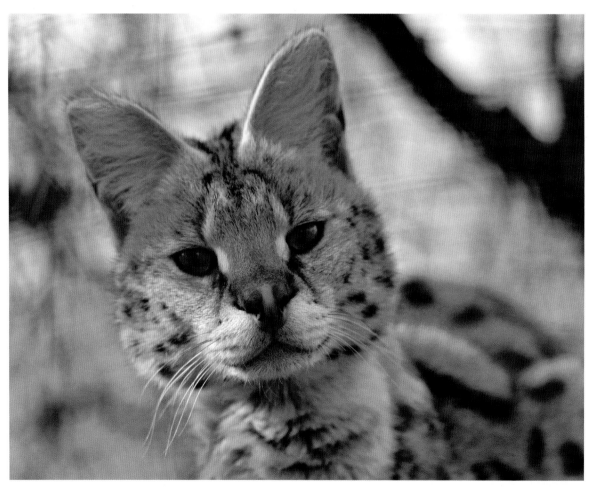

Sampson, December 23, 2014

Sampson, January 15, 2015

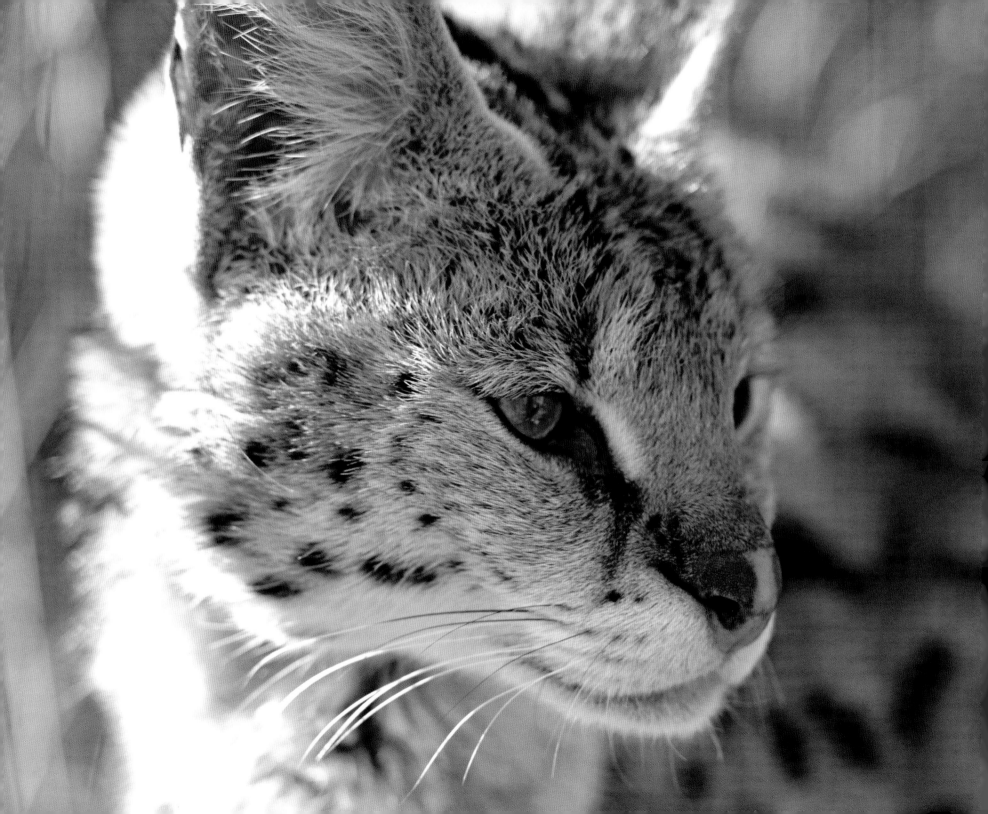

In the wake of the August 2008 mauling that resulted in the amputation of a volunteer's leg, the Wesa-A-Geh-Ya Animal Park (listed as a nonprofit corporation) in Warrenton, Missouri, closed its doors, leaving forty-nine animals without a home. A newspaper account stated that a twenty-six-year-old new volunteer was mauled while attempting to move a tiger from a large cage to a smaller one. Wesa-A-Geh-Ya operators Kenneth and Sandra Smith were charged with evidence tampering and lying to cover up the incident after blaming a pit bull instead of the tiger. According to the sheriff, "There was no way these wounds were consistent with a pit bull attack."

Wesa-A-Geh-Ya had a long and troubling history. The park closed after alleged violations of the Animal Welfare Act, fines, probation, and surrendering its USDA license.

We agreed to take Conan and Sampson III (both male tigers), who were the last two remaining animals. While the cats were well fed and the cages clean, there were numerous safety issues.

This was not our first encounter with Sampson. After an illness his previous owner, Jim Hall, had called us to ask about placement, but Hall placed him at Wesa-A-Geh-Ya because it was closer to where he lived. According to an article in the *Chicago Tribune*, Hall purchased Sampson in the parking lot of a Steak 'n Shake for $300.

Many of the cats that come to EFRC have already endured great suffering, and unfortunately some come in need of care for serious conditions. A common medical problem is severe dental disease, and the most effective way to eliminate pain, chronic infection, and other difficulties in these cats is to provide root canal procedures. Sampson needed root canals on all four canine teeth. He also required bilateral cataract surgery costing thousands of dollars.

On June 8, 2010, Sampson had his first appointment at the University of Illinois. All four canine teeth were fractured with pulp exposure, and he also had exposed root tip on a premolar and severe wear of all incisors with pulp exposure on five incisors. Upon general examination it was discovered that his toes had draining tracts secondary to fragments of nails from a previous declaw procedure. A surgical consult was requested, and x-rays were taken on all four feet to determine the extent of the problem. The draining toes were thoroughly flushed and scrubbed, antibiotics were given, and surgery to remove the fragments was to be pursued on Sampson's next visit.

Root canal therapy was then performed by Dr. Manfra Marretta on the upper right canine, the third incisor, and the lower right canine. The right first and second incisors were extracted, as was the right third premolar.

On July 13, Sampson had his second visit to the University of Illinois. Two incisors were extracted, root canal therapy was performed on the upper and lower left canine teeth, and a final filling was placed in the root canal of the lower right canine tooth. Surgery was performed to remove the ingrown nails and fragments in three toes.

On September 23, Sampson was again back at the University of Illinois for two extractions of incisors and a root canal on another incisor. Surgery was performed on his remaining two toes.

It is amazing how much better Sampson felt even after the first appointment.

Sampson III, April 24, 2010

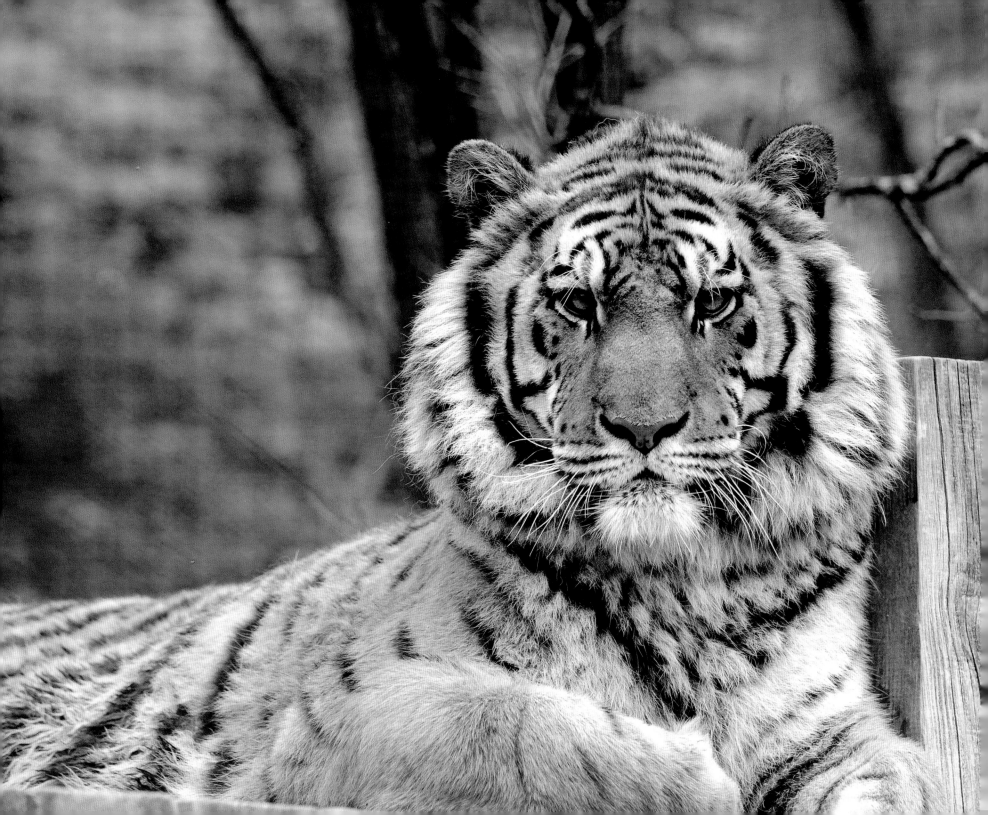

Serabi (a.k.a. Serandi) and Singa arrived at EFRC in April 2012 from Wolf Run Wildlife Refuge in Nicholasville, Kentucky. They were becoming too much for their keepers.

Singa, the female lion, was originally used as a cute cub in photographs at a roadside zoo. Unfortunately, Singa continued to grow, and like many of the cats we have rescued over the years, this proved to be a problem for her previous owners.

Serabi, Singa's male companion, was neutered at a very young age and never developed his mane. EFRC is home to both maneless male lions and female lions with manes.

Both felids adapted well to life at EFRC.

Serabi, November 30, 2014 *(both photos)*

On October 19, 2011, fifty-six exotic animals were released from their enclosures by Terry Thompson, owner of the Muskingum County Animal Farm in Zanesville, Ohio. A total of forty-nine bears, tigers, lions, and other animals were hunted down and killed by law enforcement. Soon after releasing the animals, Terry Thompson shot himself in the head. As a result, Ohio legislators passed the Dangerous Wild Animal Act. The list of "dangerous animals" included servals. Ownership by private owners was prohibited unless extremely expensive conditions were met. Future purchases were banned.

Simba, a male serval, had been a well-cared-for pet for six years. The Ohio law resulted in his owner being forced to give him up to EFRC. Simba was placed in an enclosure with two other male servals: Boi Pello and Mr. Bigglesworth. They can be seen on the EFRC tour.

The following letter was received from Simba's owner:

I obtained my Serval Simba on Nov. 13, 2007. He was just 5 weeks old. He has been a joyful addition to our family, which also includes 3 other domestic cats and our dog, for the past 6 years. Simba is in excellent health: physically, mentally and emotionally.

Simba's diet consists of a morning meal of "Zupreem" feline diet can food mixed with Friskies canned cat food. He has access to fresh water and dry cat food to crunch on throughout the day. He is in the habit of taking a hot dog to his room each night. His room is locked and he will remain, contently, there throughout the night.

Simba is litter box trained, and uses his box throughout the day and night. His litter box is cleaned daily.

Simba enjoys the company of both his human and animal family members. He eagerly engages in play activities and all five, Simba included, of our animals get along well whether they are playing or relaxing about the house, of which Simba has free rein to run and romp. He has even learned to play fetch.

He is a well mannered animal member of our family. As much as he enjoys to play he also enjoys TV time with the family as he takes advantage of being able to sit on our laps and lounge.

Simba receives regular checkups with his veterinarian at Pleasant Animal Hospital. All of his shots are up to date.

The Ohio bill passed by a wide margin. The law was created after consultation with organizations that included zoos. Perhaps they should have consulted with pet owners. The list of "dangerous animals" included the following felids, which pose little or no danger to the public: Canada lynx, Eurasian lynx, Iberian lynx, caracals, and servals. Once again politicians failed to pass intelligent animal ownership laws, and sanctuaries like EFRC pay the bills.

Simba, May 23, 2014

Swizzle

On November 25, 2009, Dona Ana County Animal Control in Las Cruces, New Mexico, captured and seized an illegally imported/possessed bobcat from a vacant mobile home. The bobcat was taken to a permitted wildlife rehabilitation facility. The New Mexico in-state rehabilitator had exhausted all funds and could no longer house the bobcat. In April 2010 the New Mexico Department of Game and Fish authorized the transfer to EFRC and Swizzle was driven to Indiana by volunteers from the wildlife facility.

Since her arrival Swizzle has had a completely new enclosure built near the EFRC motel room.

Stephen's Note: Swizzle likes her shelter so much that she is extremely difficult to photograph. Hanging out with the feeding crew is one way to catch a glimpse.

Swizzle, October 6, 2010

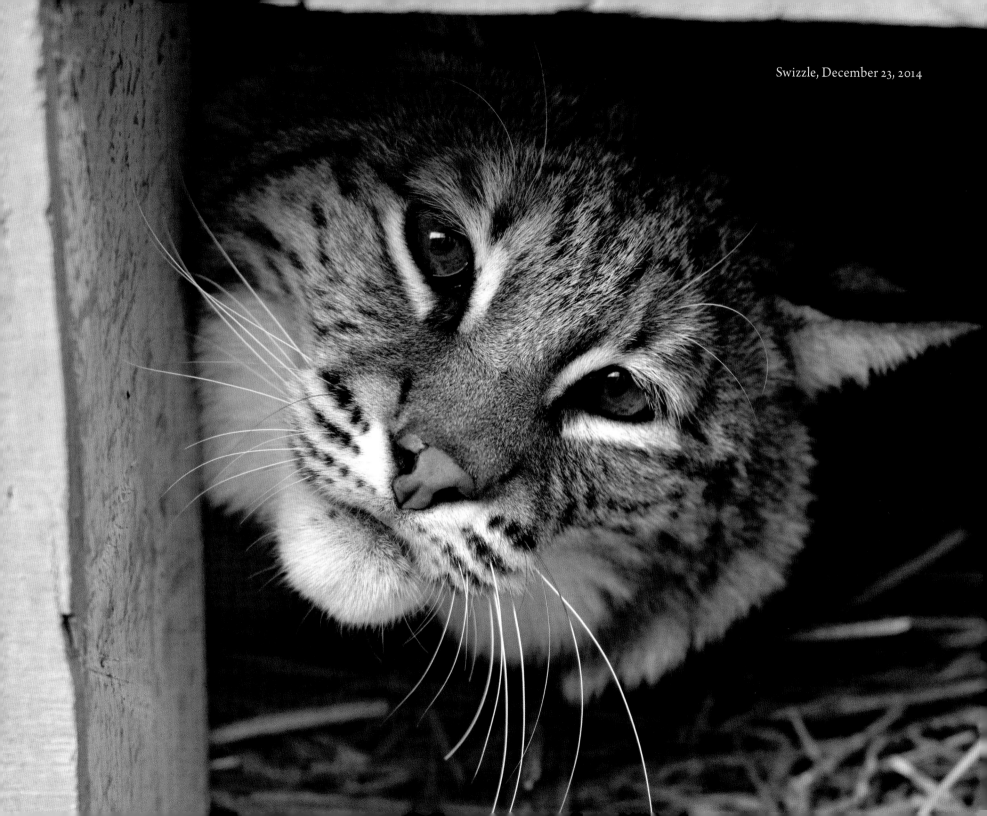

Tinker

When the Indiana Department of Natural Resources learned of Tinker, a male puma, they drove to his location in Lake Station, Indiana, every few days to evaluate him and his needs. Since his owners failed to obtain the appropriate permit, authorities confiscated Tinker on September 29, 2006, and transferred him to EFRC. He was ten years old.

Tinker was transported to EFRC by two staff members. He was placed with Lilly, another puma, until her death.

Tinker, October 10, 2006

Tinker, December 14, 2008

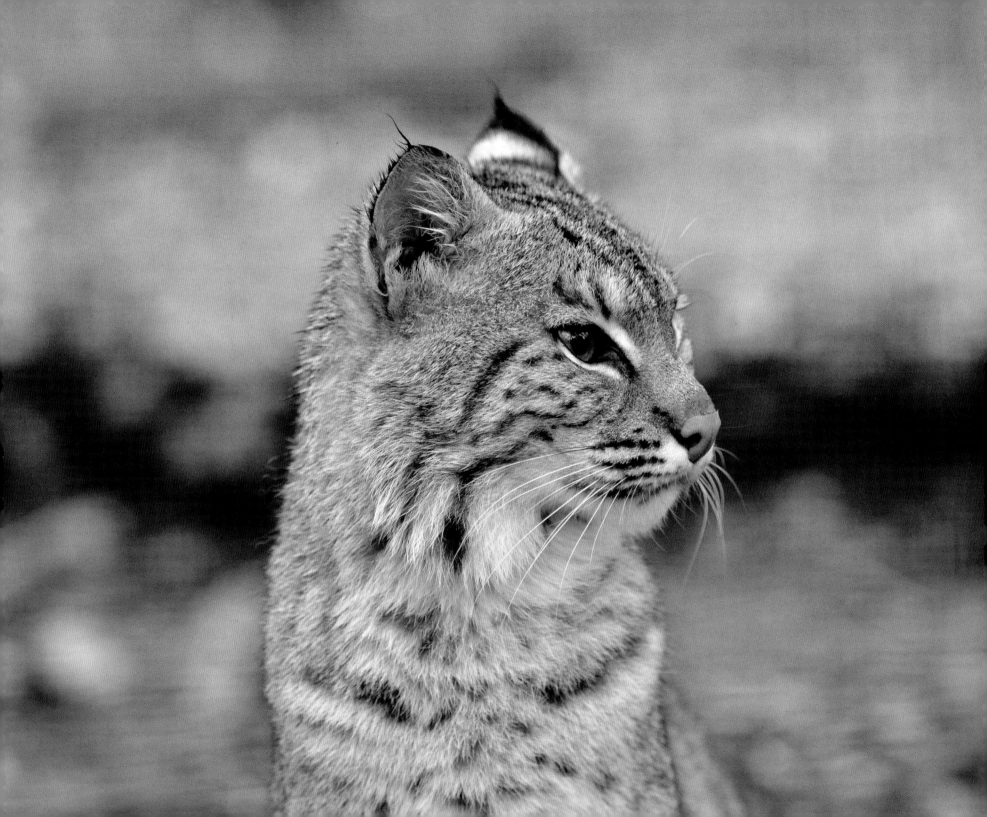

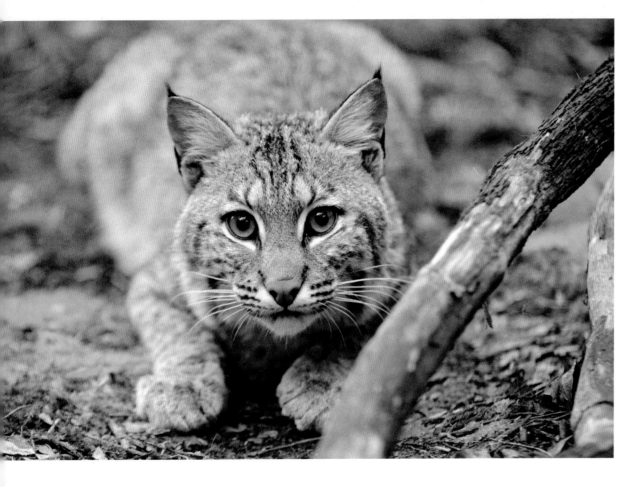

In late 2010, a man living in the Mount Vernon area of Indiana found a bobcat running around the area near his house. He started leaving his garage door open slightly so the bobcat could come and go. Everything was fine until the bobcat decided he wanted attention from people and started following them. A woman became frightened, photographed him, and contacted authorities.

In March 2011 he was seized by an Indiana conservation officer and given to a licensed wildlife rehabilitator who later transferred him to EFRC. No individual in the area had a state or federal permit to possess the bobcat, although litigation was pending regarding a permit application for him.

In 2015 he still calls EFRC home. The staff began calling him Vinnie since he came from the Vincennes area. After it was discovered that people had been calling him Bob, he ended up officially as VinnieBob, which is the name you will see on a sign during an EFRC tour.

VinnieBob lives with Cleo, a female serval. There have been times when he has seemed upset with Cleo because she was sitting in his favorite spot. Cleo manages to stand her ground with little effort.

VinnieBob, November 3, 2011 *(facing)*

VinnieBob, May 14, 2011 *(above)*

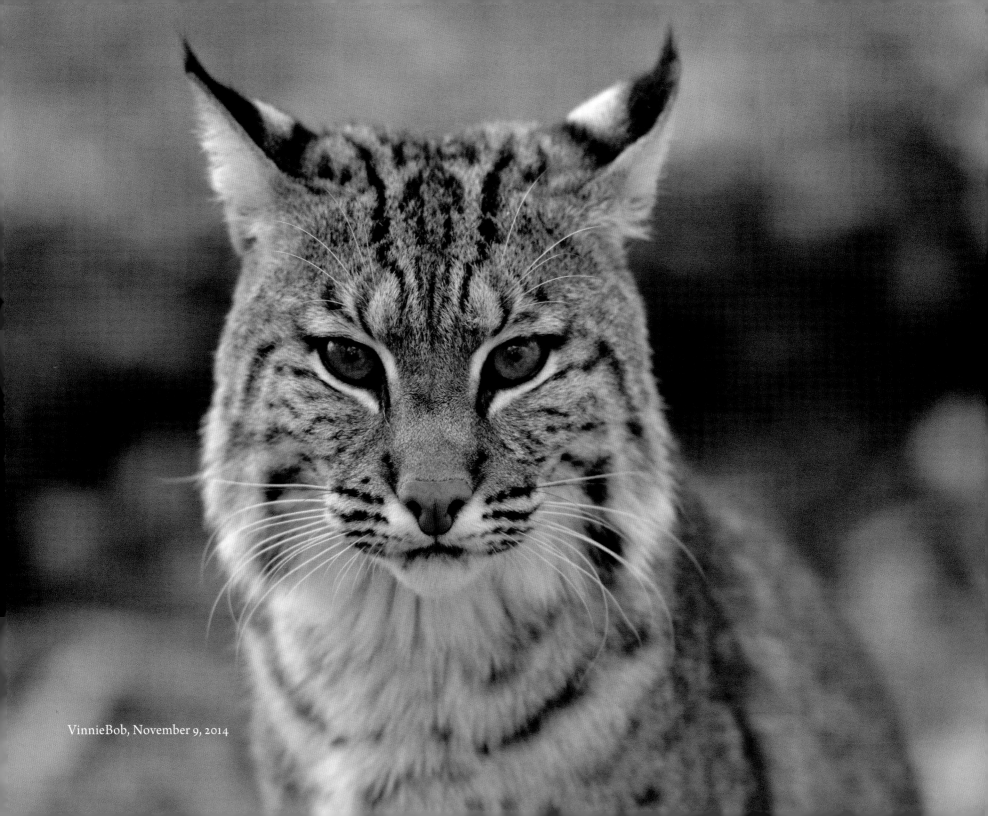

VinnieBob, November 9, 2014

Zulu and Princess

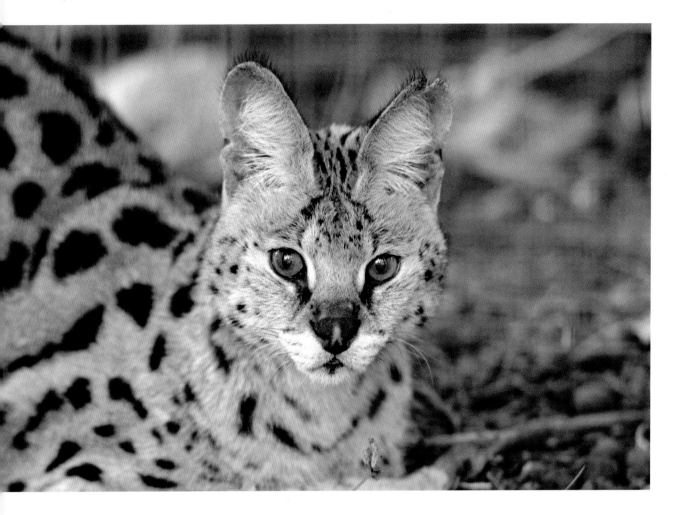

Zulu, a female serval, was purchased by a private owner in Michigan in April 1999 from Arnold's Exotics in Florida. Her date of birth was listed as February 14, 1999. Along with Princess, a female puma, she was transported to EFRC in 2014.

Stephen's Note: Zulu is unusual in that she does not give the snake hiss that most servals use to greet people. Zulu is difficult to photograph because, like most friendly felids, she comes to the fence when anyone gets near.

Zulu, August 19, 2014

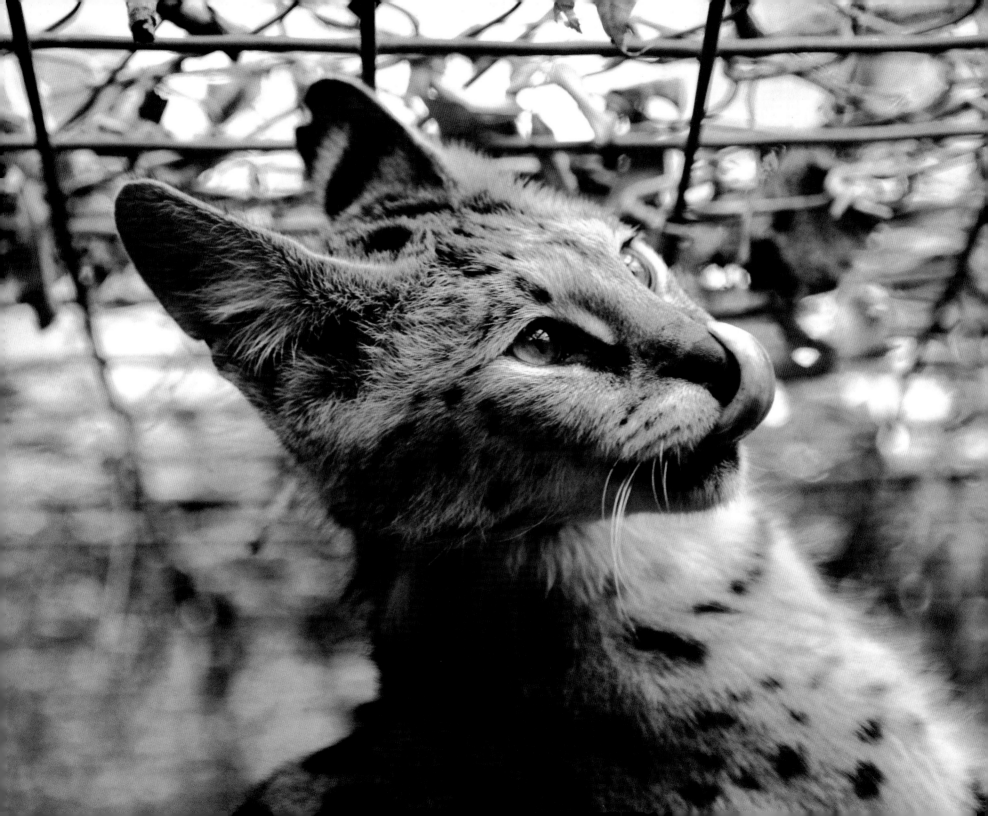

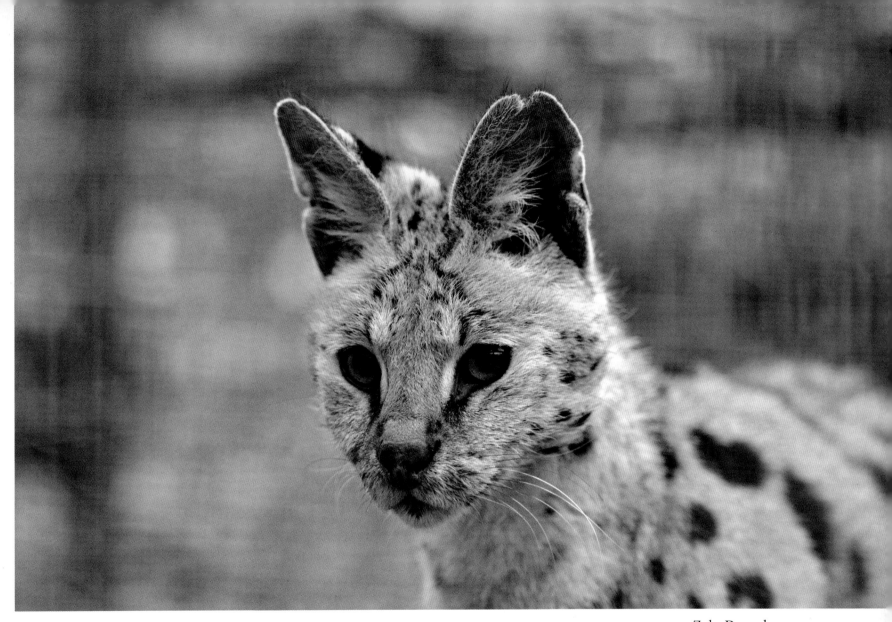

Zulu, December 10, 2014

Zulu, October 30, 2014

Zoey

Zoey is a male puma whose story is similar to Simba's. Zoey's owners lived in Ohio and were forced to give him up due to changes in state laws. He is very friendly and is still visited by his previous owners.

Zoey frequently purrs for visitors. He enjoys visitors except when he has just been fed.

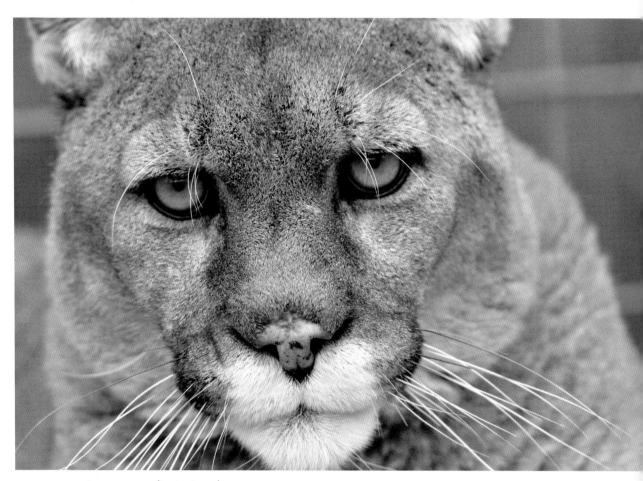

Zoey, November 30, 2014 *(both photos)*

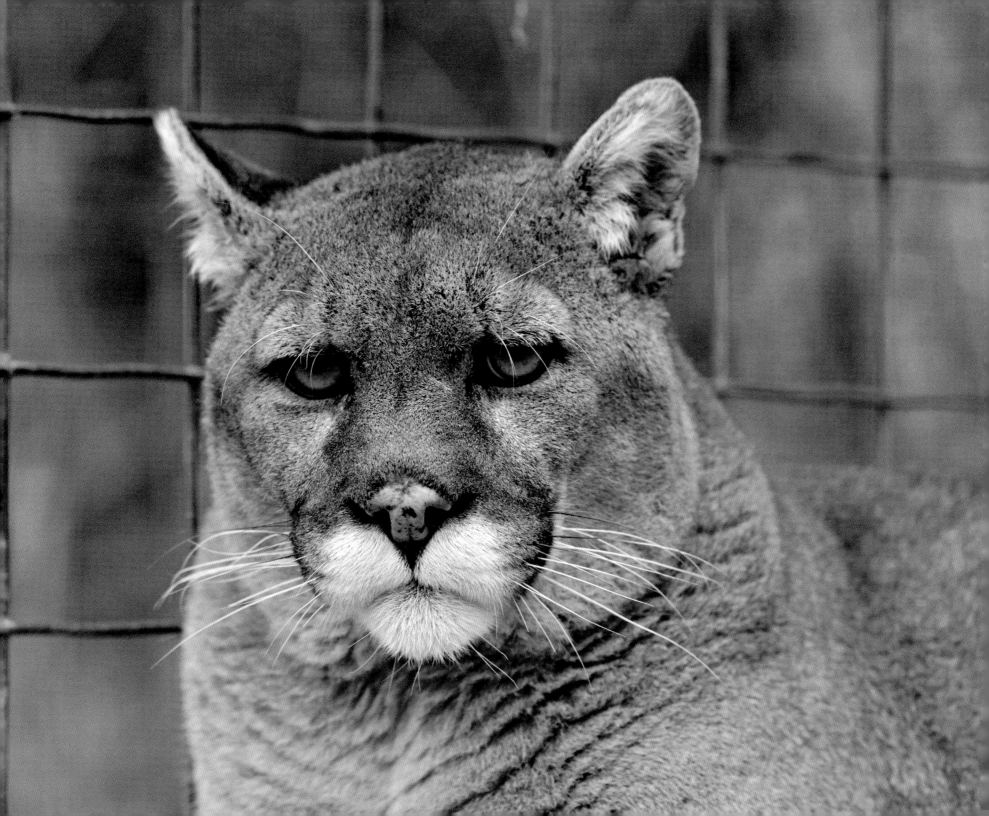

Although this is not a rescue story, it is included because of Jenny's rare (for a tiger) medical condition.

Jenny is a twelve-year-old female tiger on the main tour who lives happily in her own enclosure. Looking at her today, you would never know that Jenny is the only known tiger to recover from a debilitating condition known as fibrocartilaginous embolic myelopathy (FCEM).

It started in the fall of 2012. One day in September, the keeper noticed that Jenny, who at that time shared an enclosure with three other tigers, was down on her hind end and not moving her rear legs or tail. Right away they called Fred Froderman, the veterinarian, who immobilized Jenny in order to conduct a complete examination. Jenny was moved to the clinic area and housed in one of the two travel cages, and preliminary treatment was begun.

During the next few days, Jenny improved slightly but still did not move her hind legs or tail. On the advice of Dr. Froderman, Jenny was transported to the University of Illinois for further evaluation. On the trip, she moved her tail for the first time. At the University of Illinois Veterinary Teaching Hospital, a magnetic resonance imaging (MRI) exam revealed her diagnosis: she was suffering from FCEM.

Although it is common in domestic cats, Jenny was only the second tiger ever reported to have this disease. One lion also had the disease, but neither the tiger nor the lion recovered. There is no cure for FCEM, which occurs when fibrocartilaginous material from a spinal disc occludes blood vessels in the spinal cord, causing necrosis, or breakdown of parts of the spinal cord. Time and supportive care are the only treatments.

By the end of September, Jenny was able to stand for the first time since the disease started. She was still weak and unable to fully extend her hind legs. However, with the excellent medical, nutritional, and therapeutic care provided by the keepers, under instructions from the staff at the University of Illinois, she continued to improve slowly. By October, Jenny was standing regularly and attempting to walk. She was moved out of the clinic and into her own enclosure.

By November, Jenny was walking daily and regaining her strength and coordination. Since then, her recovery has been remarkable, as the only other exotic felids reported to have FCEM did not recover their mobility. Her improvement is attributed to the quick response of the keepers and Dr. Froderman, the expert medical staff at the University of Illinois, and the daily care provided by the Exotic Feline Rescue Center.

Jenny, November 20, 2011

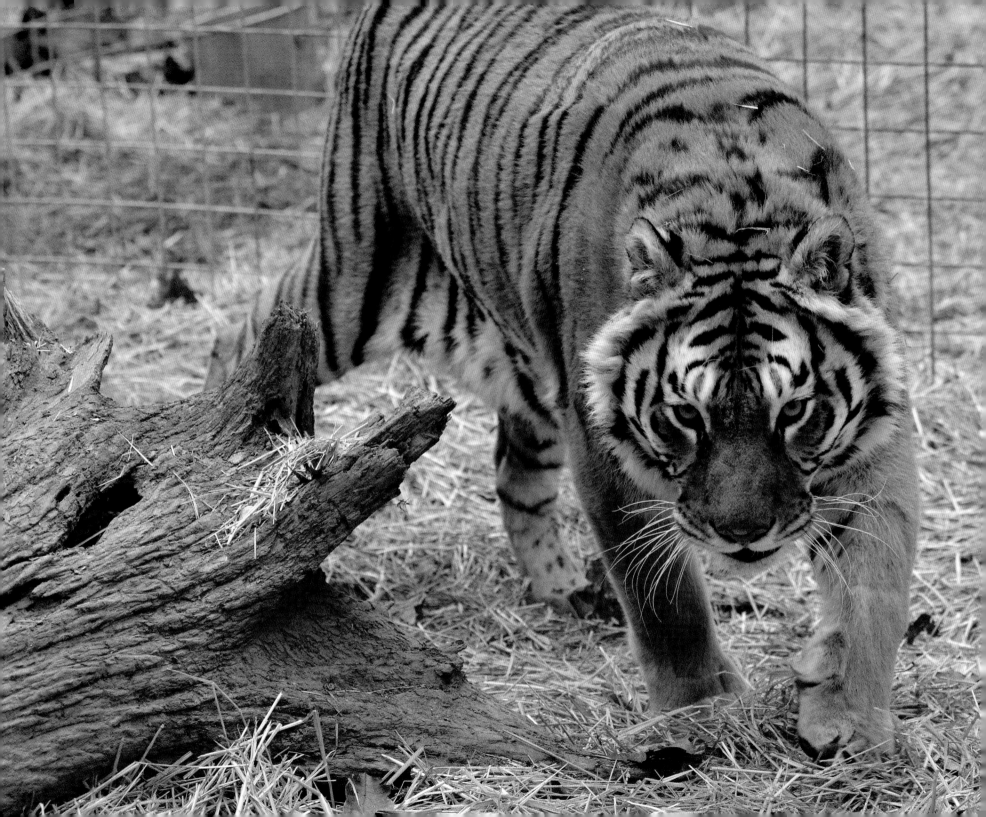

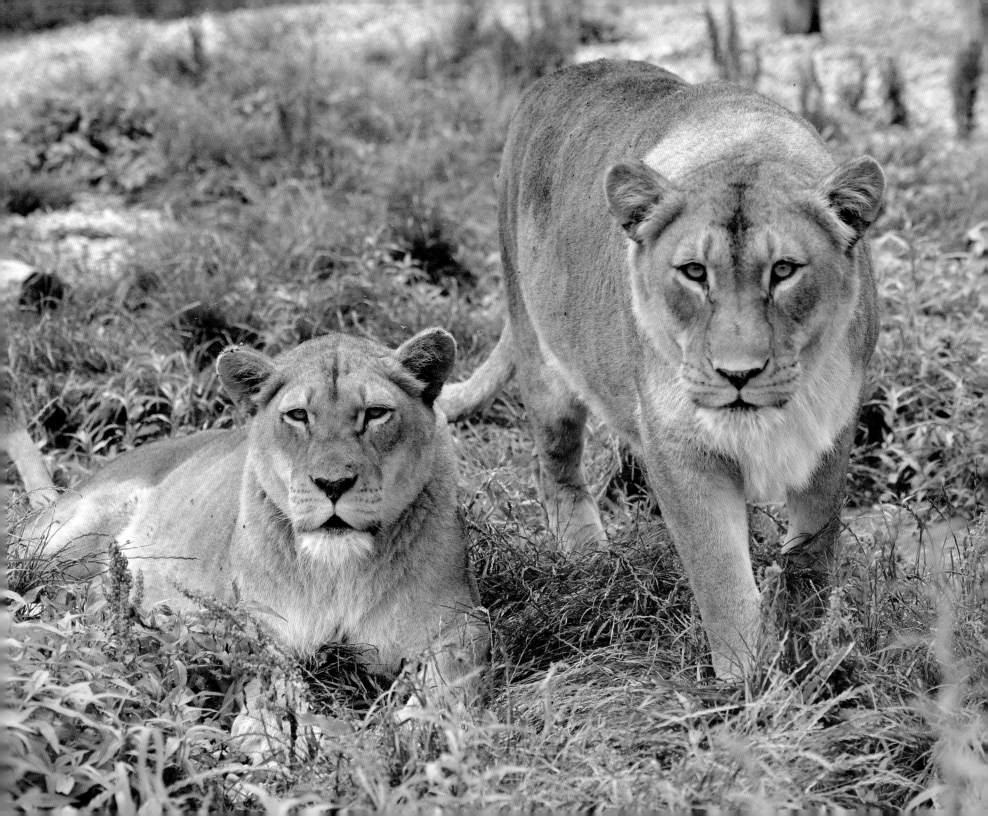

Lola, Lily, Kitty, and d'Artagnan

In July 2011 EFRC staff made a 2,100-mile trip to a rural Texas location to rescue four lions—three females and one male. They were joined by a number of cougars who were loaded and transported by the EFRC team to a rescue center in New Jersey. The lions settled into their new homes at EFRC after the lengthy journey.

It was not an ideal time to visit Texas. The heat indexes were well over one hundred degrees both there and back during the week of the rescue. To handle the trip and temperatures with maximum safety and minimal stress to the cats, a refrigerated semi truck was used, and the cats enjoyed a cool, comfortable ride during their multistate journey. A long trip always requires a snack, of course, and we turned some heads in an Arkansas Walmart with a substantial purchase of raw chicken, prompting the cashier to suggest that we were going to have one impressive barbecue.

The lions required extensive veterinary care due to prior neglect. Both Lola and d'Artagnan were taken to the University of Illinois for treatment, and both spent some time at our on-site clinic as well. At an estimated age of twenty-two, d'Artagnan was one of the oldest cats ever to be rescued by EFRC. He was much happier after the removal of an infected tooth.

Lola and Lily, June 16, 2013

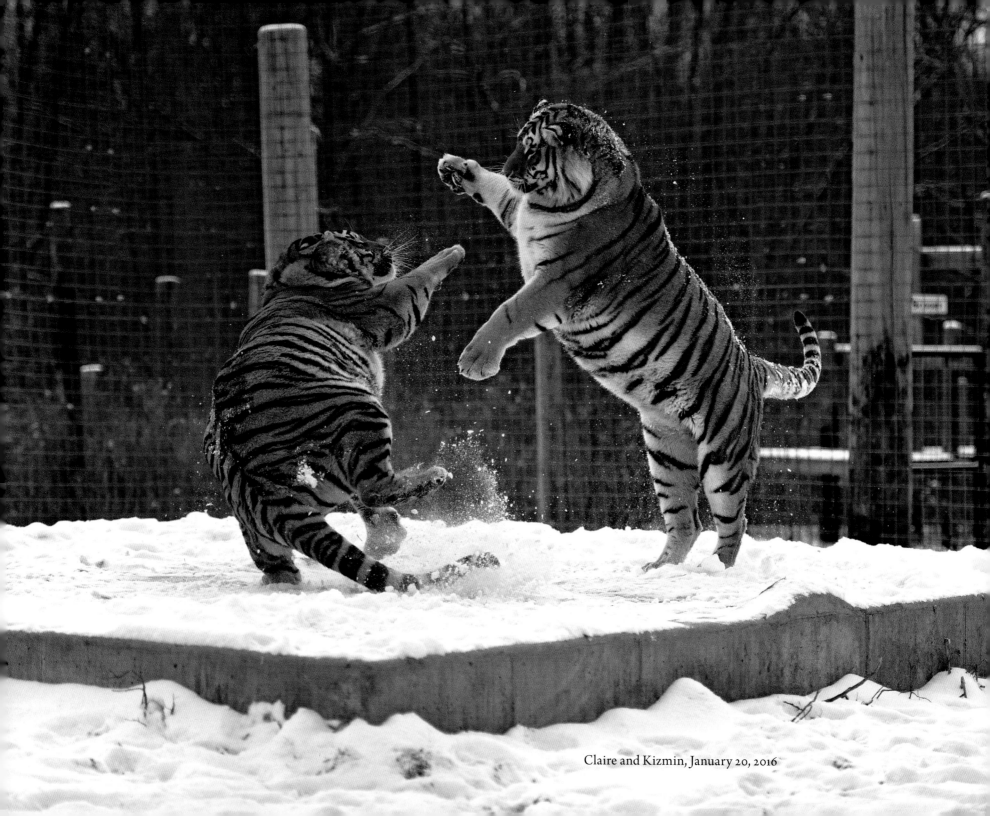

Claire and Kizmin, January 20, 2016

Frequently Asked Questions

New visitors to EFRC ask lots of questions.
These are the most common ones.

Where do the cats come from?

The abused, neglected, and abandoned felines arrive from circuses, substandard zoos, illegal owners, magic acts, photographers, and other facilities that have been closed for a variety of reasons.

Who names the cats?

If a cat arrives with a name, the cat will keep the name. If a cat arrives nameless, one can donate $500.00 to name the cat. If this does not occur, the staff will choose a name.

Why are some cats alone while others are in groups?

If cats arrive as a duo or group, the center houses them together unless hostilities arise. As a rule, newly arrived older felines remain single because of the difficulty of introducing older felines to unfamiliar felines unless both cats lived with other cats in the past. If a single cat arrives before it is one year old, attempts will be made to introduce it to another young feline if possible.

How long do the cats live?

In the wild, the big cats live seven to ten years. In captivity, it is possible for a big cat to live into its late teens or early twenties. Our oldest cat, Kashka (female tiger), lived to be twenty-three years old.

How much do the cats weigh?

At birth, lions and tigers weigh 2–3 pounds. Male lions will weigh up to 450 pounds, while tigers will weigh up to and over 600 pounds. Most leopards and pumas will weigh between 80 and 150 pounds, and the smaller felids will weigh up to 60 pounds. Servals typically weigh 30 pounds.

Do you have Siberian or Bengal tigers?

The center assumes that most of the tigers are mixes of Bengal and Amur (Siberian) subspecies. Due to inappropriate breeding practices, the cats do not arrive with papers.

Are the cats permitted to be outside of their enclosures to exercise?

No. We provide large and enriched natural habitats.

Does anyone go in with the cats?

When needed, the director, assistant director, and head keeper will go in with a select few cats. Other staff is permitted protected contact with some of the felines. Volunteers never go in with the cats.

Which cats roar?

Lions, tigers, and leopards roar, while cougars, bobcats, and servals purr.

What is a friendly cat sound?

Tigers will greet people and each other with chuffing.

Do they eat every day?

Servals, ocelots, and bobcats eat daily. Lions, tigers, and cougars will fast one day a week in the winter and two days a week in the heat of the summer. In the wild these animals do not eat every day.

Where does the meat come from?

When a farmer has a cow, calf, or horse that has died, they contact the center. A staff member travels to the farm, loads the deceased animal, and brings it back to the center where it is processed. The center also receives road-kill deer and purchases poultry.

How much meat does the center use daily?

The center uses over three thousand pounds of food, six days a week.

Why do the cats spray?

The cats spray to mark their territory.

Are bobcats as sweet as they look?

No! They are all muscle, unbelievably quick, and extremely private. They are considered the most vicious of all the small felids.

Do the cats respond to "Here, kitty kitty"?

No, but most do respond to their names if in the mood.

Does the center have a veterinarian on staff?

Fred Froderman, DVM, services the big cats at our on-site clinic. If a medical need cannot be addressed in the center's clinic, the cat is transported to the University of Illinois at Urbana-Champaign. The veterinarians from the university can perform certain procedures at the on-site clinic as well.

Do the veterinarians donate their services?

No, but the center does receive a reduction in cost.

Does the center sell cats to zoos?

No. If a cat comes to the center, it will stay at the center for its lifetime. EFRC does not buy, sell, or breed animals.

What happens to the cats when they die?

A necropsy is performed to determine the cause of death. When this is completed, the cat is cremated and its ashes are kept at the center.

How many employees does the center have?

The center employs approximately twelve full- and part-time employees. The keepers are college graduates holding degrees in zoology, biology, or animal behavior. The center also utilizes college interns and volunteers.

How can I volunteer at the center?

People interested in volunteering should visit EFRC, and then check our website for volunteer orientation. All volunteers must be eighteen years old.

How can the general public help exotic felines?

There are several ways for people to help exotic felines and relieve their plight. Never attend or participate in events which exploit animals (circuses, photo booths incorporating big cats, substandard zoos, or attractions that charge for the opportunity to touch a big cat). Never buy an exotic cat, because they are not suitable as pets. Take the time to learn about big cats, their habitats, and efforts to help save them. Take the time to learn about all endangered animals. Donate money to your favorite animal charity. (Conduct research so you can be positive that money is indeed going to animal care.) Educate your friends and family regarding big cats and their needs.

Visiting EFRC

Visitors can contact EFRC at:

Exotic Feline Rescue Center
2221 E. Ashboro Road
Center Point, IN 47840
(812) 835–1130
E-mail: efrc1@frontier.com

For more information, visit the center's website:
http://www.exoticfelinerescuecenter.org

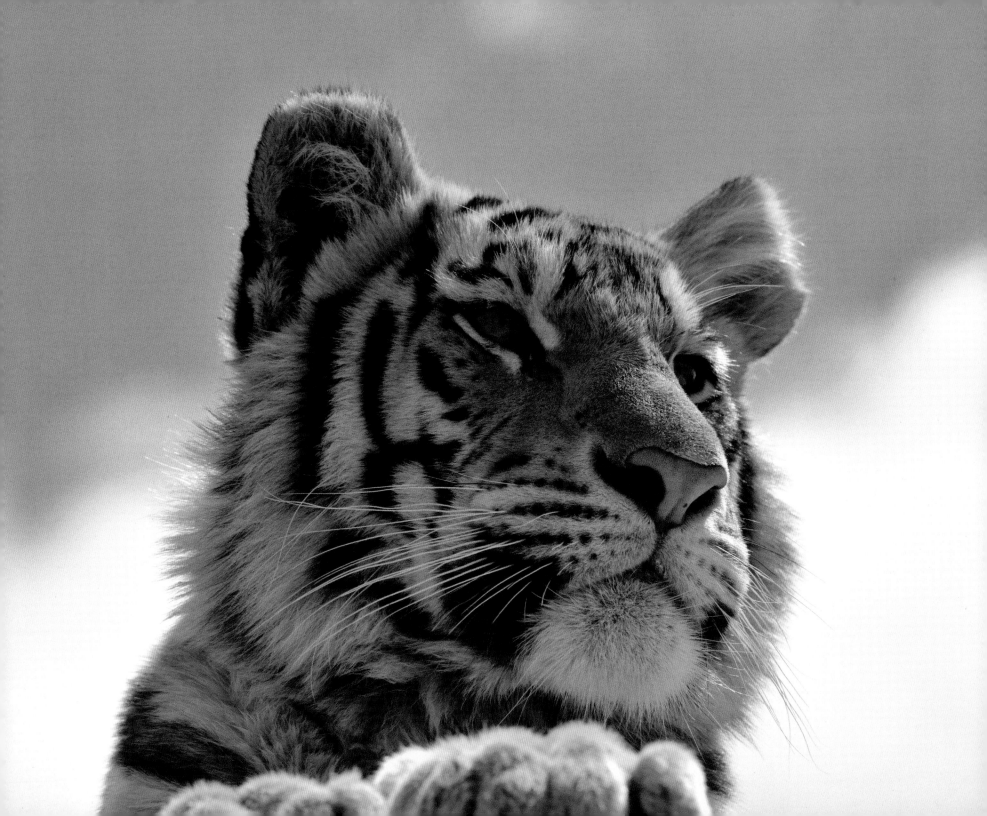

Stephen D. McCloud has been a passionate photographer since his teen years. For thirty-five years, he worked in the Information Technology Department at Indiana State University. He is now retired. McCloud's portfolio includes sports photography, natural landscapes, oddities, and exotic felines. He is a regular volunteer at EFRC.

Bill Nimmo is Founder of Tigers in America.

Joe Taft is Director and Founder of the Exotic Feline Rescue Center. He is a widely respected animal rights authority.

Chloe's cub, July 16, 2014

DIRECTOR: *Gary Dunham*
EDITOR: *Sarah Jacobi*
PROJECT MANAGER: *Nancy Lightfoot*
BOOK AND COVER DESIGNER: *Pamela Rude*
PRODUCTION COORDINATOR: *Laura Hohman*

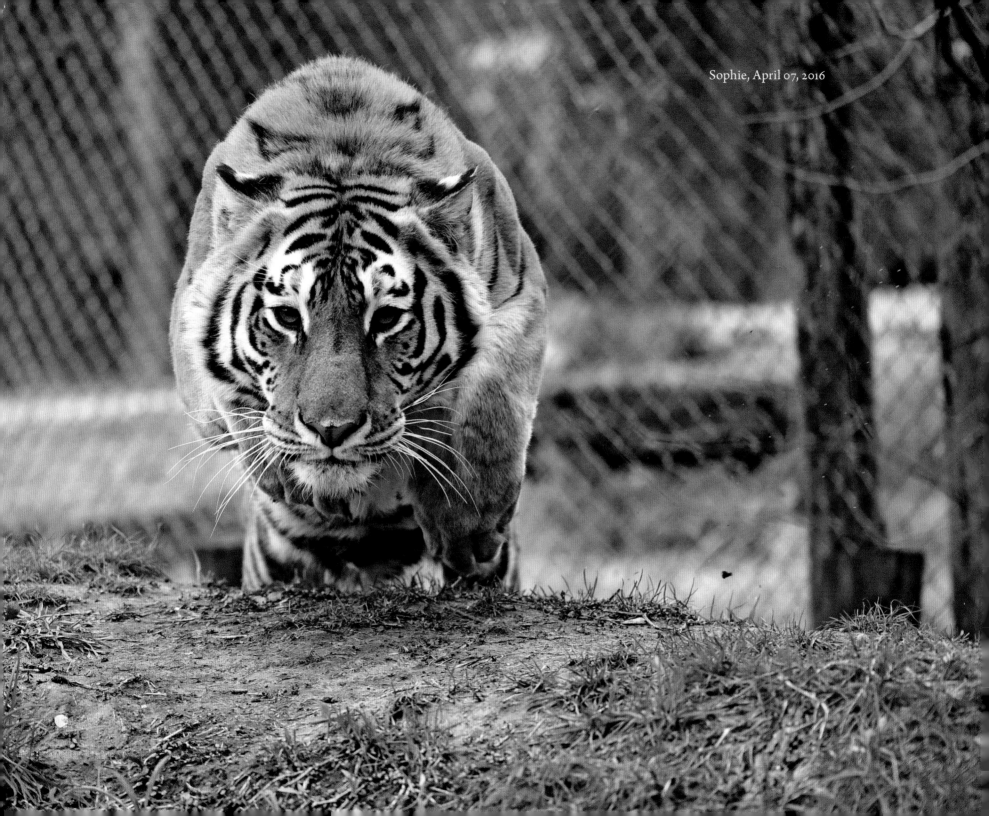

Sophie, April 07, 2016

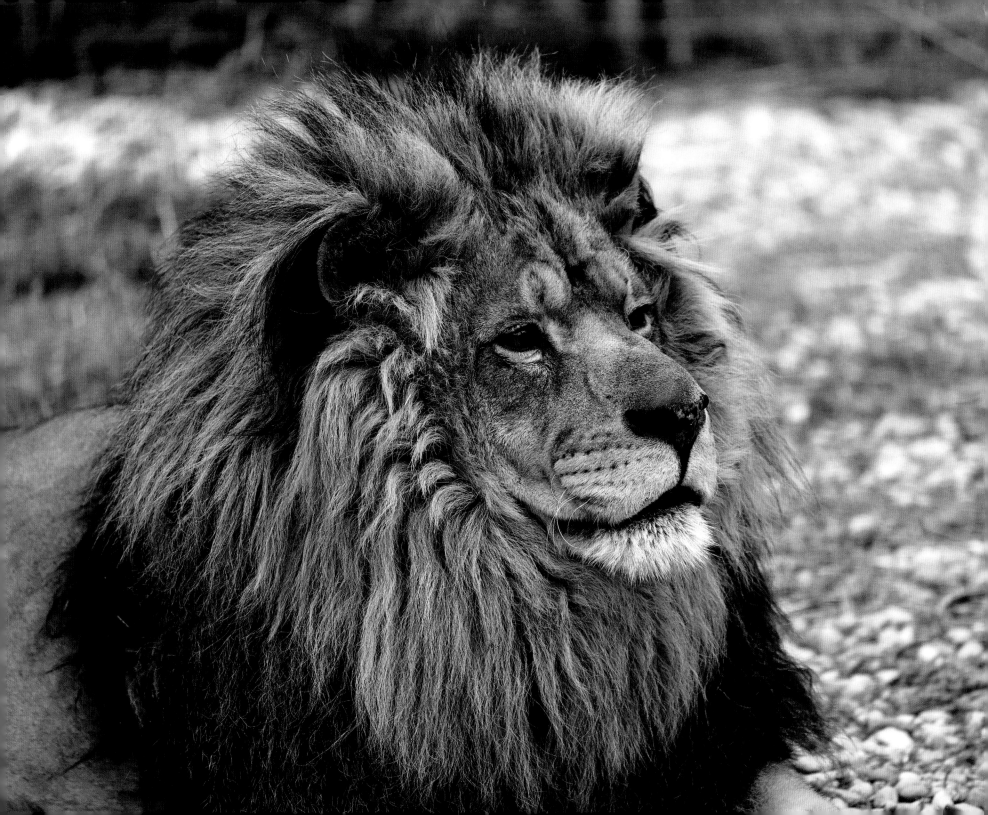

Simba, March 30, 2016

Kayla, February 20, 2016

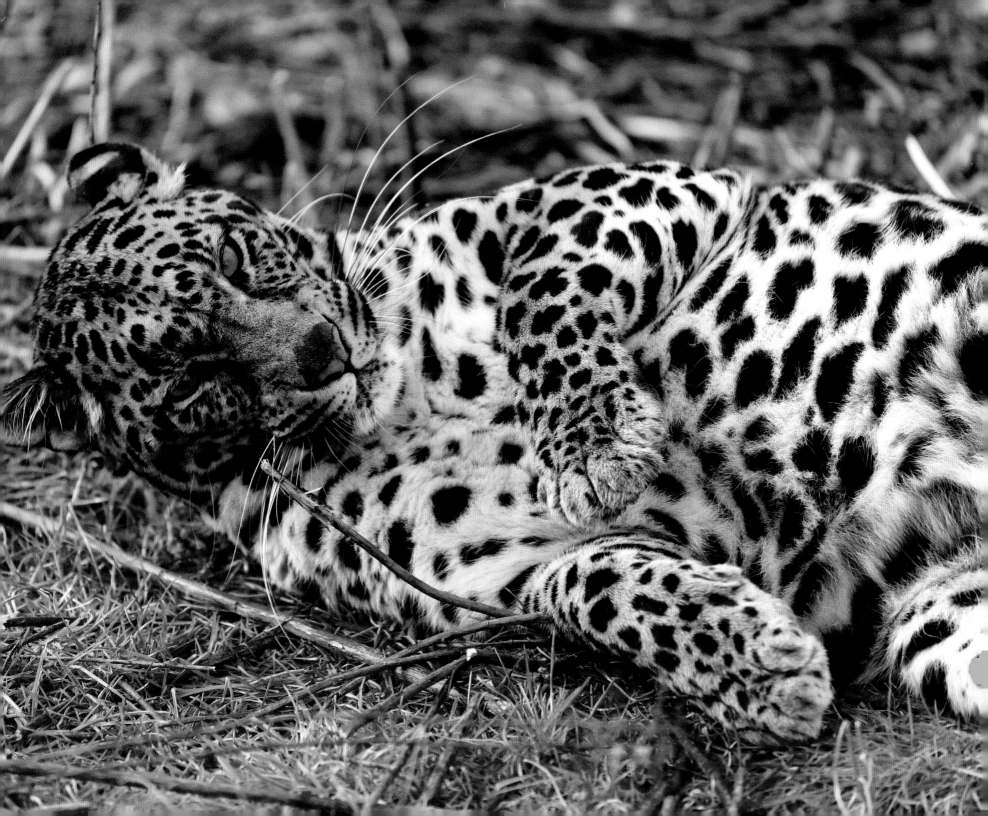

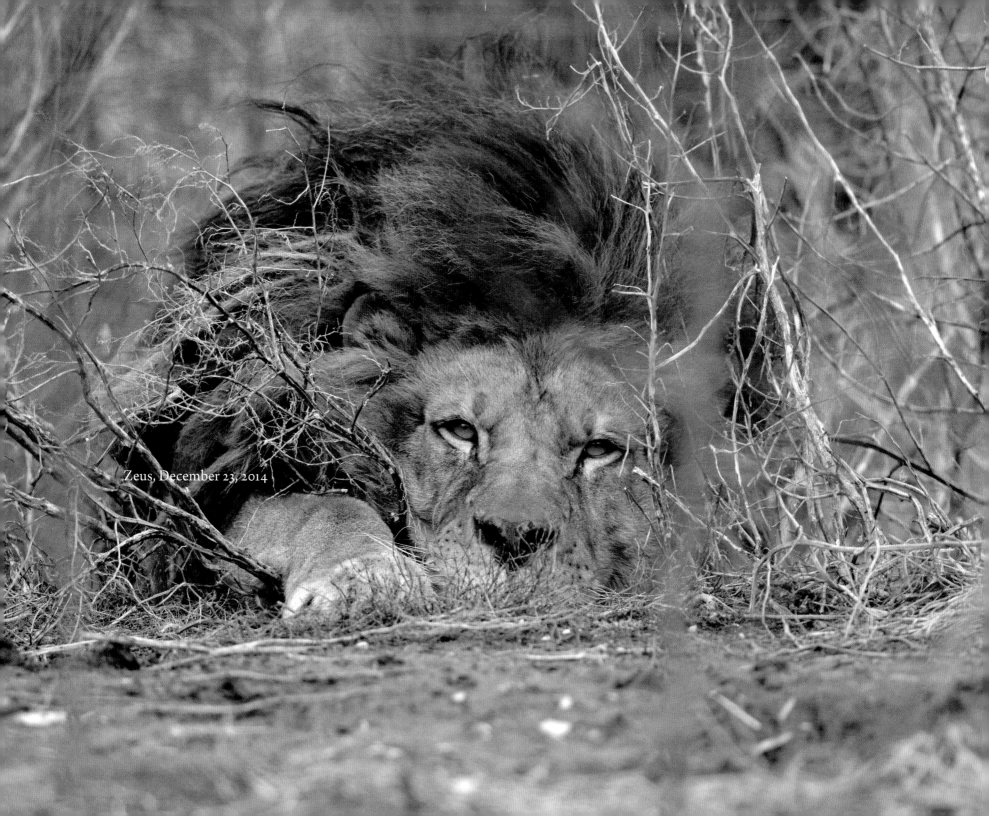

Zeus, December 23, 2014